IMAGES
*of America*

# BIG LAKE VALLEY

# Big Lake Valley
## Skagit County, WA—Early 1900s

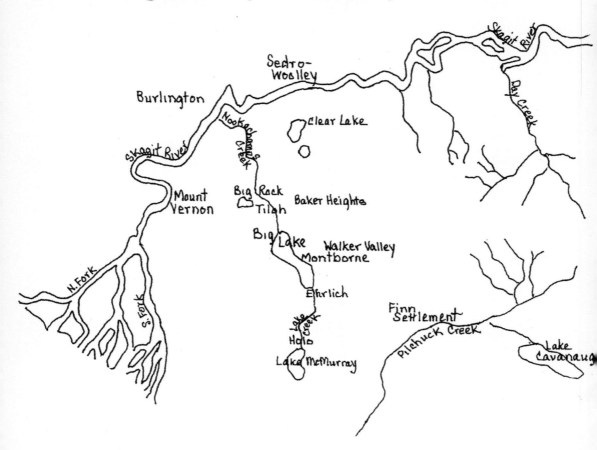

This is a re-creation of a small section of a map of Skagit County, Washington, focusing on the communities in the Big Lake Valley in the early 1900s. The center of the valley is Big Lake, a three-mile-long recreational lake located about 5.4 miles southeast of Mount Vernon on the west side of State Road 9. (Courtesy of Trudi Yarcho Davis.)

**ON THE COVER:** Built for the Day Lumber Company in 1916, the Climax No. 1405 was a powerful and reliable 80-ton steam locomotive. A three-man crew included the engineer, the fireman or stoker, and the brakeman. Seated on the engine is Henry Weppler, the brakeman. James Barringer, the engineer, is standing left at the locomotive. The other men are unidentified. (Darius Kinsey photograph; courtesy of John Weppler.)

IMAGES
*of America*

# BIG LAKE VALLEY

Big Lake Historical Society

ARCADIA
PUBLISHING

Published by Arcadia Publishing
Charleston, South Carolina

Printed in the United States of America

Library of Congress Control Number: 2015953524

For all general information, please contact Arcadia Publishing:
Telephone 843-853-2070
Fax 843-853-0044
E-mail sales@arcadiapublishing.com
For customer service and orders:
Toll-Free 1-888-313-2665

Visit us on the Internet at www.arcadiapublishing.com

*This book is dedicated to our original historians for their vision
to preserve our history and their love of the Big Lake Valley.*

# CONTENTS

# ACKNOWLEDGMENTS

Photographs credited throughout this book, along with those from the Big Lake Historical Society (BLHS) archives, insure a lasting preservation of Big Lake Valley history. Without the vision of the valley's original historians, Josephine Barringer Hoffman, Ralph Willis, Fred Meyers, Helen McInnis Millward, Effie Calkins, Inez Calkins Farmer, Mildred Markham-Granstrom Billingsley, Irene Windish, Melba Hoffman Hall, Onalee Woiwod, and Madlyn Yarcho, much of the valley's history would have been lost.

A special thank-you to those donating information and photograph collections used in this book: Jim Farmer (JF), Melba Hoffman Hall (MHH), Andrea Millward Xaver (AMX), Charles Mossington, Dale Thompson, Dennis Thompson, Alice Van Liew Anderson, John Johnson, Bill Reinard, Deanna Ammons, and the Skagit County Historical Museum. We wish to also acknowledge Darrell Drummond for his generous support and encouragement. The history in written form is now a reality.

The dedication of our writers and editors should not go without mention. The Big Lake Historical Society is greatly indebted to the following members for their determination to see the history of the valley published. The book committee members are Melba Hoffman Hall, Norma Hoffman Everett, Andrea Millward Xaver, Ida Uitto Jensen, Julia Uitto Krieger, Mary Granstrom Buzzell, Kenneth Hoffman, Gloria Hoffman, Jim Farmer, Pattie Hanstad Pleas, Madlyn Yarcho, and editors Trudi Yarcho Davis and Chris Farrow.

# INTRODUCTION

Visiting the Big Lake Valley today, there is little indication that it had once endured volcanic activity from Mount Baker or was carved out of receding glaciers. This small valley and lake, located on the Nookachamps Creek drainage and tucked between the hills with beautiful views of Mount Baker, is 5.4 miles southeast of Mount Vernon in Skagit County, Washington. Big Lake is the largest of a chain of lakes; it is approximately three miles long and is surrounded by seven communities. Big Lake is a census-designated place (CDP) with a population of 1,835 in the 2010 census. Six other communities have long been connected to Big Lake; they include the Finn Settlement, Ehrlich, Montborne, Walker Valley, Big Rock, and Baker Heights.

It is rare to find any sign of the earliest inhabitants, the Noo-qua-cha-mish Indians, or any of the earliest settlers. By the mid-1880s, the Big Lake Valley had become a destination for many young men and their families in search of land and new beginnings. With local residents building new homes and cities and towns in the Pacific Northwest growing at a remarkable pace, lumber became a much sought-after commodity. Shingle mills and lumber mills lined the shoreline of the lake in the late 1800s and early 1900s, and the timber industry thrived in the Big Lake Valley.

Hugh Walker and Dr. Hyacinthe P. Montborne were both building shingle mills in 1887. Hugh Walker set up his at Walker Valley, and Dr. Montborne established his at the town that would bear his name. Shingle mills were also eventually built at Ehrlich, the Finn Settlement, and Big Lake.

A group of Finnish speaking homesteaders, some seeking timber claims as part of the Timber Culture Act of 1873, settled deep in the woods along Pilchuck Creek and near Lake Cavanaugh in 1891, where they cut cedar bolts for the mills downstream, worked in logging camps, and farmed. Charles Granstrom, one of those early settlers, successfully grew four varieties of tobacco. This community, first called Pleasant Valley, became known as the Finn Settlement.

The Theiler family settled the south end of Big Lake in 1886, and the area became known as Theiler's Spur with the arrival of the railroad. In 1894, Frank Ehrlich arrived and built a shingle mill, and the community was renamed Ehrlich. Cedar bolts from Sumner Lake, Holo, and Lake McMurray fed the mill.

In the early 1900s, the Day Lumber Company set up a large lumber mill at the north end of Big Lake with housing and a townsite of its own that became Big Lake. Nelson-Neal Lumber Company had outgrown its operations at Clear Lake and set up a lumber mill at the town of Montborne in 1903. The two lumber mills offered much-needed employment to local residents and also employed many men from outside the area. Fires were the hazard for all of the mills.

The Knapp Brick and Tile Company of Everett, Washington, incorporated in 1911, building a brick and tile factory at Tiloh, Washington, which was located on the east side of Big Rock. Tiloh had its own small general store used by the workers, the company, and the local residents. The Knapp Brick and Tile Company managed to keep men employed from 1911 to 1944, when the factory closed. Tiloh, Washington, no longer exists, and the location is simply known as Big Rock.

In Baker Heights, the Gunderson, Carlson, and Johnson families, the early settlers, arrived after the Skagit Railway and Lumber Company had logged the area. They were challenged with clearing the land of stumps and log slash left by the logging. Soon farms sprang up and more families arrived; agriculture became important to sustaining the economy of the new community. By 1922, the community was large enough to support a new two-classroom schoolhouse.

The shingle mills and the lumber mills are long gone, and activity around the lake has evolved from the once-bustling mill operations to recreation, relaxation, and water sport activities. Smoke and steam from once-thriving mills have been replaced with the sound of powerboats pulling wake boarders and jet skiers racing and pounding the wakes.

From the late 1940s into the 1980s, population in the communities of the Big Lake Valley remained stable. For years, families took their water from the lake, treated or not, or had shallow wells. Outhouses were still common in the earlier years, and sewage from those lucky enough to have indoor plumbing seeped its way down into the lake. Some years green algae would be so dense that a few people hesitated to swim, but it did not stop those more determined.

The Big Lake water system utilized the water from wells drilled on the old mill site. The Montborne Improvement Club developed a water system in 1953 with a reservoir at the top of Montborne Road. The transition from hand pumps and outhouses had begun, and indoor plumbing became a new luxury in most homes.

In 1980, a sewer plant was built at Big Lake with lines serving part of the community. The cost of the sewer system and water system proved to be a hardship for many, forcing many longtime residents to sell and move from the area. Once the Skagit Public Utility District (PUD) became involved in the sewer and water system, suburban expansion came to the Big Lake Valley. Some small homes were replaced with larger houses, and the development of planned residential communities began.

Fish and game in the Big Lake Valley were always in abundance, and fishing today on Big Lake continues to be a pleasure enjoyed by residents and visitors. Many species of fish can be found in the lake: largemouth bass, yellow perch, pumpkinseed sunfish, and small numbers of cutthroat trout and black crappie are available. A public boat launch on the southwest side of the lake offers easy access for fishermen and their boats or anyone wanting to enjoy time on the water.

Primarily a residential community, today the valley is complete with a 1950s-themed bar and grill, a nine-hole golf course, a growing elementary school, a community store and church, and an outstanding fire department.

An Independence Day celebration happens each year on the third of July at Big Lake. Through donations and strong community support of homeowners and spectators, the fire department has put on a fireworks display since 1963 that rivals those of larger cities.

Photographs and historical information contained in the pages of this book ensure that the legacies of those who have passed will not be lost. The Big Lake Historical Society members are dedicated to continued research, thus preserving the history of the Big Lake Valley. Those original historians, with their vision for the Big Lake Valley, are very much appreciated. To quote words spoken by Onalee Woiwod to Josephine Barringer Hoffman at an early historical display, "Look what we started Josephine, aren't you proud!"

# One

# EARLY TIMES

Long before settlers, Noo-qua-cha-mish Indians occupied areas in and around what are now Mount Vernon, Burlington, Sedro-Woolley, Clear Lake, Big Lake, Lake McMurray, Nookachamps Creek, and part of the Skagit River.

Noo-qua-cha-mish villages were built along fresh waterways and varied in size depending on number of residents, time of year, and activities in which the family or tribe was involved. Villages offered familial surroundings and protection.

Hunting, gathering of plants, trading for necessary items, and potlatches were common among local tribes. The local dialect spoken was Kik-i-allus. The Chinook language was used as trade jargon with tribes outside local tribal territories. Shovel-nosed canoes were used on the Skagit River and its tributaries.

The Noo-qua-cha-mish had rich oral legends, among them that of the Star Child, born after his mother's return to earth from an unhappy marriage to a man in *illahee* (land) in the sky. She returned to earth by means of a long rope woven from cedar saplings. When she reached earth, her sister, who remained in the sky, cut the rope to conceal the method of escape. The rope fell, coil upon coil, and formed the present Big Rock. Star Child later returned to the sky and lights it at night. His wife's face can be seen in the moon.

In the mid-1800s, immigrant men arrived, and some married Indian women, had families, and created different lifestyles. While change was inevitable, few could speculate the future. Some tribes signed the Indian Treaty of Point Elliott in 1855; Ch-lah-ben represented the Noo-qua-cha-mish.

Indians eventually sought employment within logging, milling, farming, and other industries. Indians and settlers continued to mingle, more marriages occurred, and families became blended. Some identified with newcomers, others with tribal families, depending on tribal class distinctions.

Cedar was very important to the native culture. The small home built of cedar planks is representative of Noo-qua-cha-mish permanent houses. Their tools, such as hammer handles, were often made of strong wood, and a stone was tied to one end of the hammer for pounding. Sharpened bones were also used for adzes and chisels. Wooden pegs, leather or cedar straps, and woven vegetation held boards in place. Houses were adjacent to water for safety, ease of transportation, and domestic use. The Noo-qua-cha-mish built shovel-nosed canoes, propelled by paddles and poles, for use on the Skagit River and tributaries; there were very few trails. Tribal master craftsmen hollowed out cedar logs for these versatile canoes, often five feet wide and 50 feet long, for fishing and transportation. Occasionally tribal people transported early settlers to their homes. (AMX.)

Above is a longhouse, or clan house, built as a permanent residence for several families. Heavy cedar logs and timbers were used, and construction was labor-intensive. Benches for seating and sleeping were built along the interior of the walls. Heat came from open fires tended in the middle of the house. Totem poles are not noted with Noo-qua-cha-mish. However, large, upright interior house posts were often decorated. O.K. Pressentin, from an early pioneer family, described a longhouse near Illabot Creek reported to be 1,000 feet long. Longhouses offered protection and hospitality, such as hosting potlatches, which observed special events. Cattail-mat houses were used primarily in the summer season. The mats were tied to poles by strips of bark or leather. The mats could be removed and relocated to other sites as they traveled to gather food, plants, and other items necessary for yearlong subsistence. (AMX.)

In a c. 1914 studio portrait, Martha Buck Fellows is holding her grandson, Franklin Fellows Christofferson. Standing is his mother, Alice Fellows Christofferson. Seated is Franklin Buck, Martha's father. Missing is Franklin's deceased wife, Maggie, part Noo-qua-cha-mish from her father. Family records show her mother's tribe as Whace Stolic. Maggie's Indian first name was Sacquolitsa. When Franklin's wealthy family confirmed he married Maggie, they disowned him. (Courtesy of Jeanette Stakkeland Forshier.)

Pictured around 1919 on the family farm on Beaver Lake Road, near Clear Lake, are Alice Fellows Christofferson, of Noo-qua-cha-mish descent, and Louis Christofferson with their children, from left to right, Franklin Fellows, Olive Catherine, Martha Madeline, and James Christian. Catherine Christofferson later married Melvin Thomas Stakkeland; James Christian Christofferson married Margaret Sylvia Stakkeland. Many Christofferson and Stakkeland descendants still remain in Skagit County. (Courtesy of Jeanette Stakkeland Forshier.)

# Two

# THE WALKER VALLEY

Hugh Walker and his family were the first to settle Walker Valley in 1887. Between 1888 and 1910, more settlers followed, including the families of J.S. Thompson, Albert Gilpin, Fred Nichol, Frank Reinard, Richard Cantlin, and Charlie Washburn. The James Dunlap family came into Walker Valley about the same time as the Walker family and constructed a shingle mill where some of the men were employed.

As the trees were cut and sent to the mills, the land was cleared. Agriculture became the dominant way of making a living. Milk from the small dairy farms that emerged was sold to families in Montborne. During World Wars I and II, many of the valley's young men were drafted into the armed forces, leaving the farms shorthanded. Several coal mines briefly opened in the area.

A scenic place, the valley is located in the foothills of Cultus Mountain, and the landscape is dotted with small creeks and lakes where residents and guests enjoyed fishing and picnicking. It is located within three miles of the town of Montborne, where the valley families would send their children to school and participate in community activities such as dances, baseball, or church.

Hugh Walker was an early settler in the Walker Valley and its namesake. He and his wife, Ellen; their two daughters, Lizza and Rhetta; and stepson Albert Gilpin homesteaded in the valley in 1888. Hugh and some of the other settlers spent 87 days cutting a road to Mount Vernon. In 1890, he helped lay the tracks for the Seattle, Lake Shore & Eastern Railroad Company, which was finished in 1892. Hugh owned and built the first shingle mill. Below, in the 1890s, many families operated small shingle mills, where stumps and logs from old-growth cedar were cut into shingles for roofing and siding in Walker Valley. The people worked long and hard in the shingle mill to provide for their families. (Both, BLHS.)

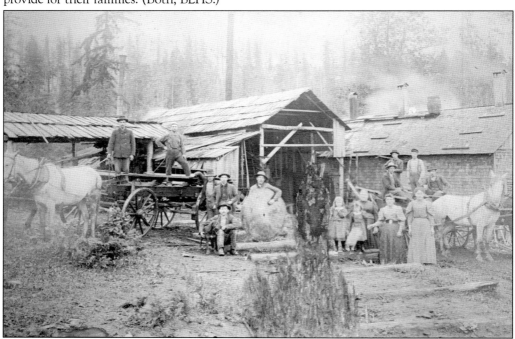

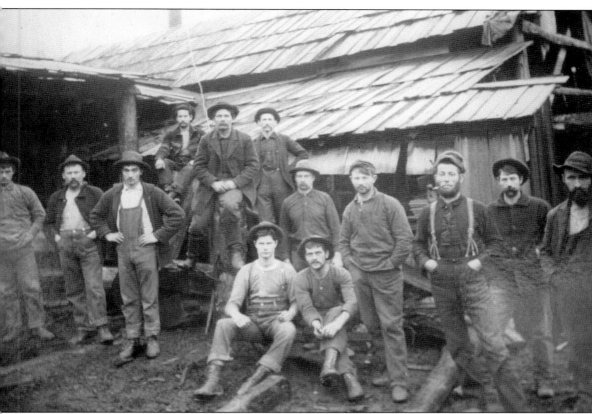

These shingle mill workers in the Walker Valley in the early 1900s were often single men and immigrants who worked as sawyers, filers, and shingle weavers. Some of these workers lived in Montborne and travelled back and forth each day because there were no accommodations in the valley. The three-foot shakes on the roof of the mill were common at that time because of the abundance of old-growth cedar. (BLHS.)

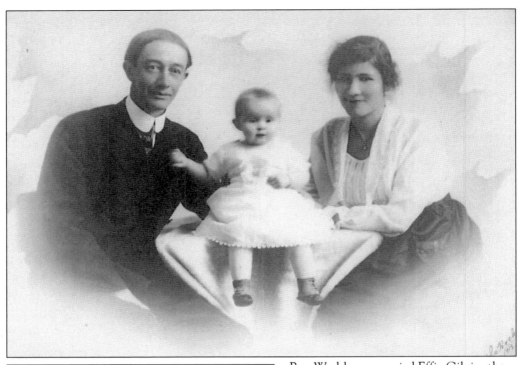

Ray Washburn married Effie Gilpin, the granddaughter of Hugh Walker. Effie was born and raised in Montborne and Walker Valley; she was attractive and very popular. One of the first families in the valley, they were involved in logging. This photograph, taken in 1925, is with their first child, Marintha. (BLHS.)

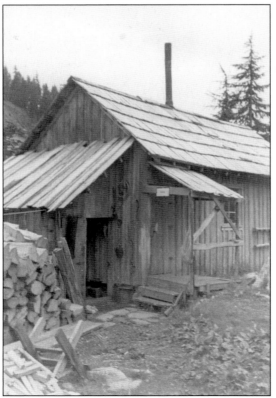

This rescue cabin, commonly called the Washburn Cabin, is one of many that was used by people who were in the woods and in need of shelter. They were usually stocked with enough comforts to allow for a safe stay until they could move on. The Washburn Cabin was on Cultus Mountain above Walker Valley around 1940. (MHH.)

Richard and Julia Cantlin were photographed on their wedding day in 1902. They made their first home in Walker Valley and began farming there in 1905. They were active in the community until the 1950s, when they moved from the valley as Richard's health began to fail. (Courtesy of Mae Cantlin Hoffman.)

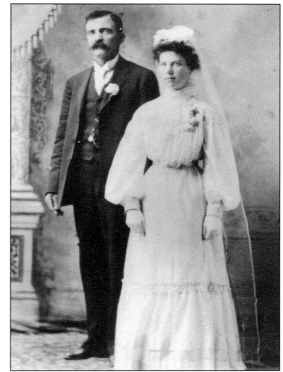

The horse-drawn Studebaker buggy was ready to take the Cantlin family— Richard and Julia; their daughters, Julie, Frances, and Mae; and their son, Tommy—into Mount Vernon on a monthly shopping trip. The 10-mile buggy ride was an all-day excursion. This photograph was taken around 1921 in front of the family home in Walker Valley. (Courtesy of John Cantlin.)

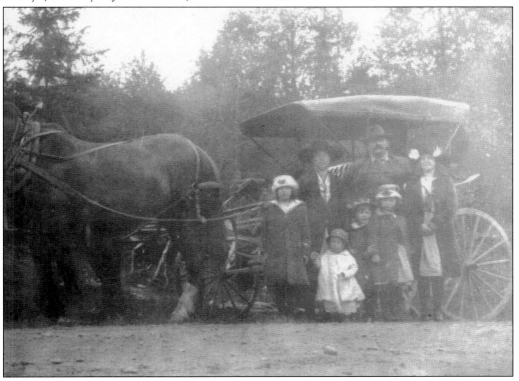

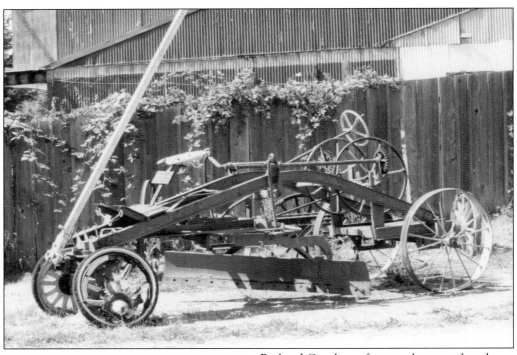

Richard Cantlin, a farmer, also served as the county road supervisor for 14 years, from 1914 to 1928; he never missed a day of work. He was responsible for road maintenance between Big Lake and Ehrlich. He operated a road grader exactly like this one, photographed in front of an establishment in Concrete, Washington, in 1995. (Courtesy of Ken Hoffman.)

Tommy Cantlin, pictured as a six-year-old in 1925, grew up in the valley and was drafted into the Army during World War II. He wrote to his sisters regularly and dreamed of having his own family one day. He gave his life for his country and became a casualty of war on September 11, 1944. (Courtesy of Ken Hoffman.)

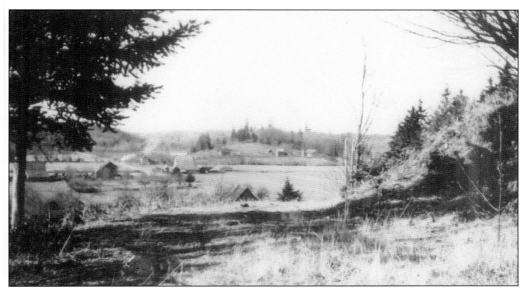

Walker Valley lies in the foothills of Cultus Mountain. In the 1930s, electricity had not yet come to the valley. In the foreground is Hugh Walker's home and property. Smoke is rising from the farmhouse of the Cantlin farm. Julia Cantlin was known as one of the best cooks in the valley. (Courtesy of the Schacht family.)

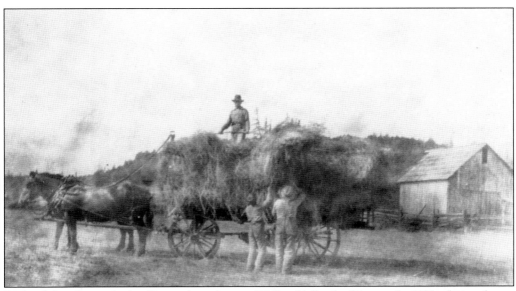

Richard Cantlin worked a 40-acre dairy farm in Walker Valley for 50 years. In 1935, a horse-drawn wagon was still in use on the Cantlin farm to bring in the hay. Richard (right), his son John (left), and an unidentified helper (on wagon) are loading the wagon. In the background is the barn that was used to store the hay and shelter the livestock. (Courtesy of Mae Cantlin Hoffman.)

Francis Cantlin and her nephew Jack Bailey sit on a Model T sedan and enjoy some watermelon around 1930. He was a talented baseball player and had signed to play for the Pittsburg Pirates before going into the Army. While serving in the military, he helped build a baseball park for children in Munich, Germany. Jack was killed in an auto accident in Germany in 1947. (Courtesy of Mae Cantlin Hoffman.)

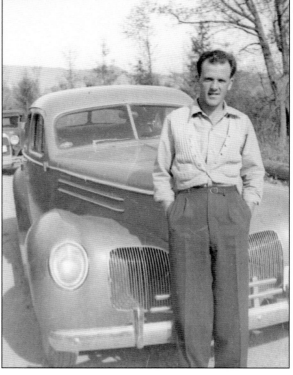

Jack Bailey's uncle, Tommy Cantlin, standing in front of a 1939 Studebaker, was raised in Walker Valley and attended school in Montborne. He joined the Army Air Corps in 1942 and served in the South Pacific and China as a belly gunner. He was killed in action while parachuting after his B-24 was shot down near Kunming, China. (Courtesy of Mae Cantlin Hoffman.)

A happy Mae Cantlin stands in front of a Model T on the day of her wedding to Lloyd Hoffman, July 3, 1934. The automobile was a wedding gift from Lloyd's brothers. Mae and Lloyd Hoffman raised five children and celebrated 51 years of marriage. Mae and her siblings attended school in Montborne. People who lived in the valley relied on Montborne for school and entertainment. (Courtesy of Mae Cantlin Hoffman.)

It was a beautiful summer day in 1943 when Lloyd Hoffman took his two children, Virginia and Ken, out for a day of fishing on Walker Creek. Salmon would spawn in the creek in the fall, but in the summer, trout were plentiful and perfect for dinner. (Courtesy of Ken Hoffman.)

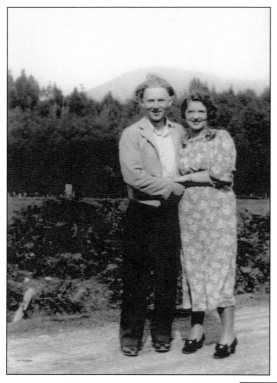

Thor and Francis Cantlin Nersten are pictured in 1935. She grew up in Walker Valley, while he was raised in Ehrlich, a community south of Big Lake. They were a fun and popular couple in the valley. He was one of the first fire commissioners for the Big Lake Fire Department. They had nine children; two of the children, Sam and Marie, are shown below in 1943. Marie died tragically when she was only six years old. Sam grew up and eventually married a Walker Valley girl, Lois Knopf. Their three sons remained in the region. (Left, courtesy of the Nersten family; below, courtesy of the Lloyd Hoffman family.)

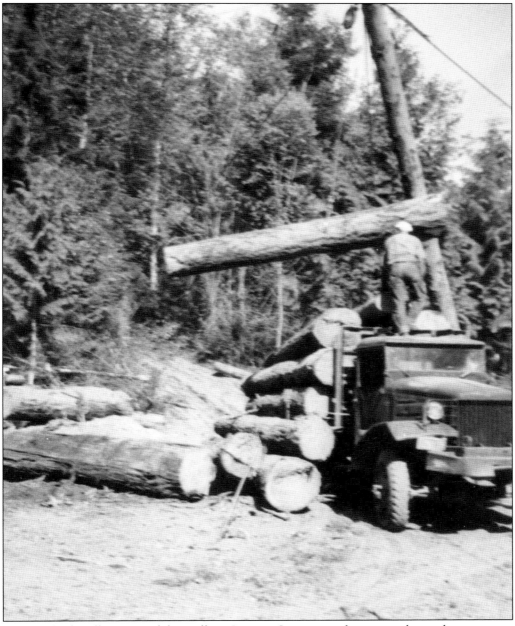

In 1951, Lloyd Hoffman started the Hoffman Logging Company with a war surplus truck, equipment, and personnel from his family. His logging operation began on 20 acres of his property in Walker Valley that had second-growth cedar and fir. The business ran into difficulty and was forced to close in 1953. Hoffman continued to live in the area for many years before moving to Arizona. (Courtesy of Mae Cantlin Hoffman.)

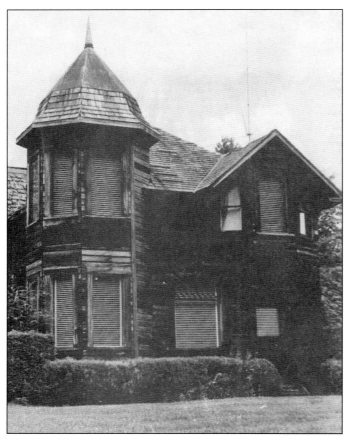

The Reinard place was built in 1907 and stood until 2005. Frank Reinard and his wife, Pat, lived there many years. Frank's father claimed to be a grand duke of Luxembourg who married a commoner. They came to the United States in the late 1800s. He later built this house, which was eventually featured in an early *New York Times* article because of its character. Frank Reinard, rather hermit-like, was highly intelligent. He had devices to hear anyone talking on his property, and stories abound that he wrapped a telephone pole with wire to access telephone use and pulled electricity off wire coils he placed near electrical poles. He built a scale-model, detailed, futuristic exhibit called "Space City," displayed from 1955 to 1963. It attracted many curiosity-seekers, including classes from Big Lake Elementary. (Both, courtesy of Clay Imhof.)

# *Three*

# MONTBORNE

Dr. Hyacinthe P. Montborne homesteaded this land in 1884, building his house, the first in Montborne, with materials hauled over a trail from Mount Vernon. Once reaching Big Lake, the materials were towed across the lake by rowboat to their destination.

While Hugh Walker was settling in Walker Valley and building a mill in 1887, Dr. Montborne built a shingle mill in Montborne. However, he was a better doctor than a lumberman, and the business soon collapsed and went into receivership. The shingle mill burned.

In 1889, Dr. Montborne hired the Fairhaven Land Company (FLC) to plat the town of Montborne. Nelson Bennett of the FLC anticipated that his railroad, the Fairhaven & Southern, would be the first to reach the town. However, the Seattle, Lake Shore & Eastern Railway Company reached Montborne first. A.S. Dunham, already president of the railway, became president of the Virginia Land and Townsite Company and purchased Dr. Montborne's claim to the town in 1890. The Montborne railroad station was soon established. A post office was then secured, and on August 11, 1891, Dr. Montborne was appointed postmaster.

John Nelson and Frank Neal constructed a new lumber mill in 1903 under the direction of Henry Waechter. The town of Montborne eventually had its own store, hotel, boardinghouse, post office, train depot, and Woman's Christian Temperance Union (WCTU) hall, as well as other buildings and businesses.

John Nelson died in 1913, and Frank Neal took over the company. Logging railroads had been constructed, allowing extensive logging in the Walker Valley, Bryant, and Devils Lake areas. In 1924, the Nelson-Neal mill employed 75 men. Frank Neal died that year, and the mill was sold in 1926 to the Montborne Lumber Company, which suffered many losses. B.H. Jones turned the remains of the lumber mill into a shingle mill. The Montborne School burned down in 1937, and it consolidated with Big Lake and eventually the Sedro-Woolley District. The transition to a residential community began.

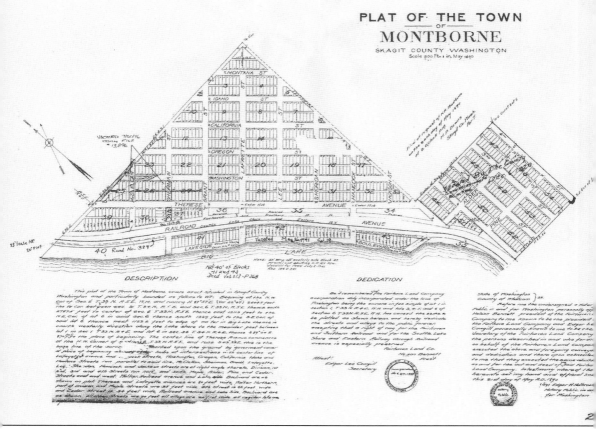

Dr. Hyacinthe P. Montborne, a prominent Mount Vernon physician and pharmacist, had big dreams. The plat of the town of Montborne was filed with Skagit County in 1889. The FLC laid out Montborne's town, as shown on this plat map. Nelson Bennett of the FLC thought his railroad, the Fair Haven & Southern, would cross the Skagit River and serve Montborne. However, the Seattle, Lake Shore & Eastern Railroad got there first, and in 1890, the Virginia Land and Townsite Company bought the plat. In 1891, A.S. Dunham, president of the company, began the development of Montborne with the construction of a railroad depot, followed by a hotel and a post office. The original plat confirms the beginning of a city, on paper at least. The streets were named for presidents, states, and people the doctor knew. (BLHS.)

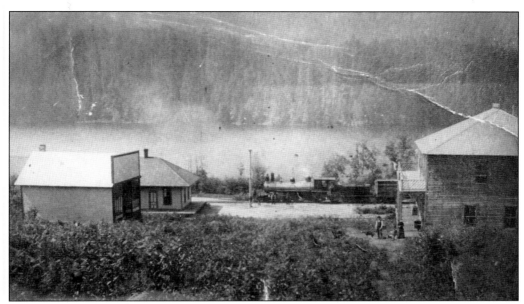

The railroad station, shown above left, and the first hotel, shown above right, depict the beginning of the town of Montborne in this early-1890s photograph. In 1891, the hotel pictured below also served as the original boardinghouse, later becoming a casualty of fire. A new hotel and saloon on the south side of Lafayette Street and a new boardinghouse on the north side replaced it. Those pictured in the middle group of five on the porch are, from left to right, Joe Lagault, Albert Gilpin, Jane Gilpin, Lizza Lagault, and Osie Phillips, who is leaning against the post. (Both, JF.)

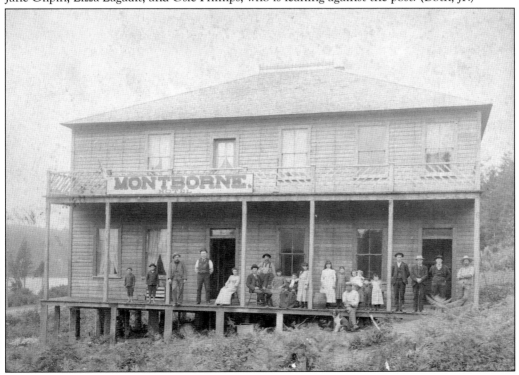

Looking eastward around 1908 up Lafayette Street at Montborne, the Nelson-Neal Lumber Company Store and Montborne Post Office are in the first building on the left. Up the boardwalk from the store and post office is the boardinghouse. The bell tower of the first schoolhouse can be seen in the upper center background. (JF.)

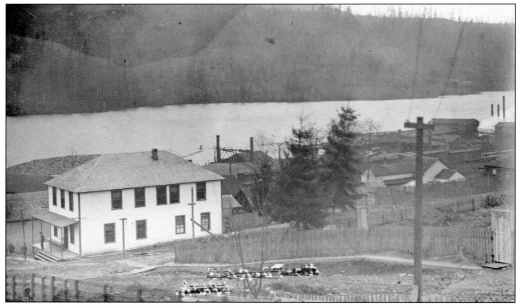

Down Lafayette Street below the boardinghouse around 1908, logs are floating in the lake, waiting to be processed at the mill. The mill spreads northerly along the shoreline. A lane runs diagonally on this side of the boardinghouse, eventually becoming Highway 1A and later State Route 9. The fenced area on the upper side of the boardinghouse later became the location for the Montborne Tavern. (JF.)

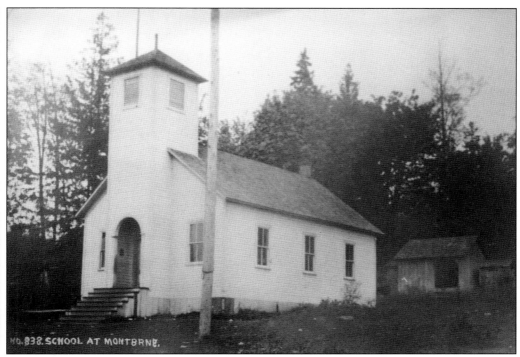

NO. 838. SCHOOL AT MONTBORNE.

Above, the first school was built in the 1890s. Children known to attend the first school were Elza Calkins, Arvid Nelson, Bud (Ray) Gifford, Pickles Milliron, H. Brick Nelson, Pat (Bert) Gifford, Gus (August) VanSinderen, Guy Coffee, Jim Bresee, Reid Nelson, Gladys Bresee, Hedvig Chase, Florence King, Capitola Chase, Connie Nelson, Orville Haywood, Alma Nelson, Annie Jensen, Basil Tovrea, Clarence Gilroy, Arthur Phillips, Guy Hoyt, Sid VanSinderen, Dan Tovrea, Hilmer Nelson, Roy Phillips, Art Dunlap, and Esther Nelson. The first school was replaced on the same site by the second school. In the 1914 photograph of the second school, below, is seven-year-old Inez Calkins, third child from the right; the others are unidentified. The school burned in 1937. The district then consolidated with Big Lake. (Both, JF.)

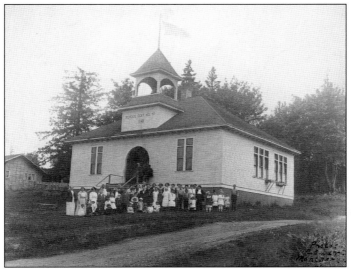

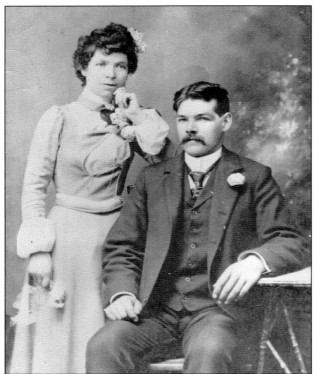

Three-year-old Osie Violet Phillips left Missouri on a wagon train with her father, brothers, and sisters. She was 10 years old when she arrived in Walker Valley to live with older sister Diza Dunlap and Diza's husband, James, about 1887. William Roger Calkins came to Montborne in the 1890s. William Calkins and Osie Phillips were married in Seattle in 1901 and made their home in Montborne. (JF.)

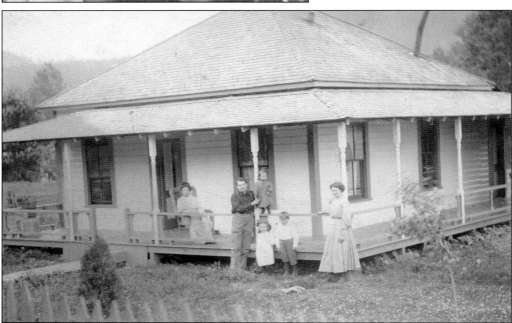

At the Calkins family home, Osie Calkins, seated, is expecting baby Ethel. William Calkins is holding Inez on the rail, with Mable below and son Elza next. The girl at right is unidentified. They bought the house in 1901. All their children and most grandchildren were born in this home. The house was the polling place for the Montborne precinct for nearly 40 years. (JF.)

Andrew Anderson built a home in Montborne at the top of Lee Street overlooking beautiful Big Lake. The town of Montborne could be seen from his home. The house still stands today. Anderson married Ada Zillah Glenn, right, at Clear Lake in 1905. The couple is pictured below about 1919 with their children on the front porch steps. From left to right are Andrew Anderson with daughter Alice, sons Forest and Harold (center front), daughters Elaine and Elna (center back), and Ada Zilla Glenn Anderson with daughter Ada Phyllis. Alice Anderson and her mother, Ada Zillah Anderson, died one day apart in 1935. Andrew Anderson died in 1936. Forest Anderson was Big Lake's fire chief for many years. (Right, courtesy of Lyle Archer; below, courtesy of John Schmidt.)

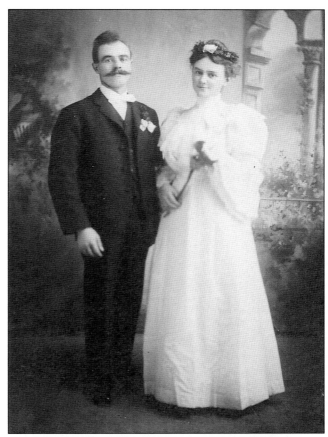

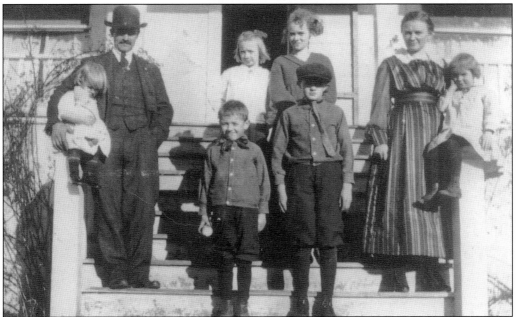

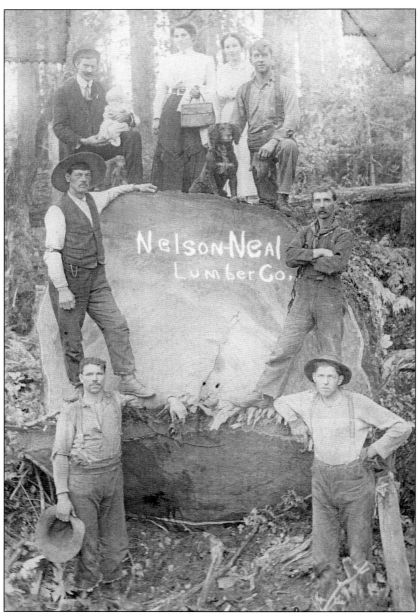

The Jake Bartl family, the Schrader family, and the Turner family make a pretty picture around 1909 at this large tree felled by the Nelson-Neal Lumber Company. Mary Francis Bartl Turner stands on top holding a purse or basket next to Margaret Turner as John Turner kneels beside the dog. In 1903, John Nelson and Frank S. Neal moved from Clear Lake and began operations on the east shoreline of Big Lake. In 1906, Norman Lind of Everett bought an interest in the firm. The company incorporated under the name of the Nelson-Neal Lumber Company. John Nelson was president, Frank S. Neal was vice president, and Norman Lind was secretary and treasurer. Sam O. Hoyt was superintendent, and Henry Waechter kept mill equipment in good repair. The population of Montborne in 1913 was reported as 250, and the company employed about 100 men. (BLHS.)

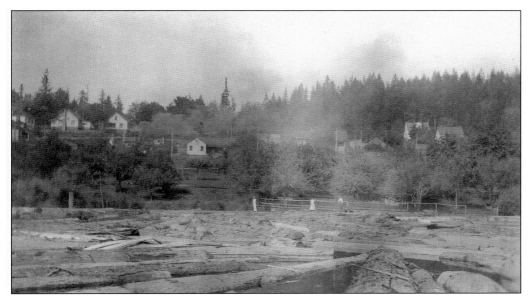

The Nelson-Neal Lumber Company mill at Montborne was built in 1903 under the direction of Henry Waechter after the Nelson-Neal partnership outgrew its shingle operation near Clear Lake. Seventy men could turn out 40,000 board feet of lumber and 140,000 shingles each day. The drying kilns, lumber sheds, and yard were stacked with lumber awaiting shipment to growing cities to the south. Above, logs are on the lake waiting to enter the mill, and below, boxcars are ready to haul the lumber and shingles away. It was not unusual to have two million board feet on hand in the yard. Montborne began thriving, and the mill offered new hope to the growing community. (Above, BLHS; below, JF.)

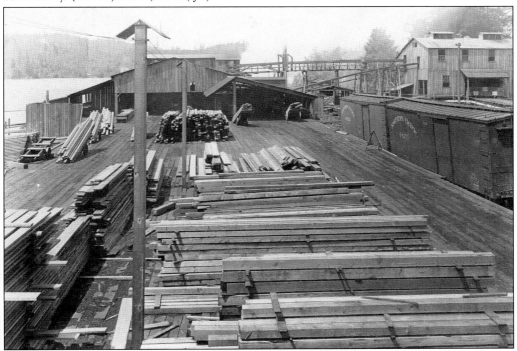

John Nelson of Nelson-Neal Lumber Company lived with his wife, Sophia, and their children in this home on the north side of Lafayette Street. This house is still standing today and can be seen directly behind the current Big Lake Bar and Grill. John Nelson was born in 1865 and died in 1913. (BLHS.)

Frank S. Neal of the Nelson-Neal Lumber Company lived in this home on the right side of Lafayette Street with his wife, Rose, and daughter Nellie. This home also stands today. Frank S. Neal was born in 1856. He had not been very active in the company until the death of his partner, John Nelson, in 1913. Frank S. Neal died in 1924. (BLHS.)

William Calkins, left, is standing on the porch of the Nelson-Neal Lumber building that housed the company office, the store, and the post office. Others pictured in this c. 1910 photograph are unidentified. Calkins managed the company store, spending most of his time at his place of business, yet he still found time to farm. (BLHS.)

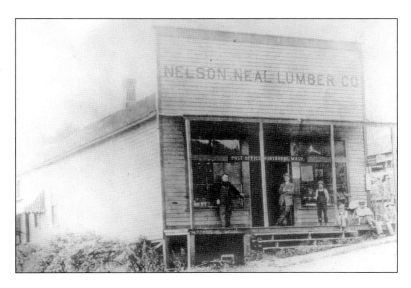

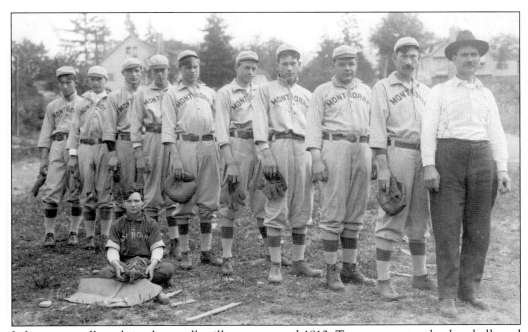

Life was not all work in the small mill town around 1910. Teams came to play baseball, and locals came to watch. The players in this photograph are, from left to right, Art Phillips, Roy Coffee, Henry Coffee, Sid VanSinderen, John VanSinderen, Henry VanSinderen, Guy Hoyt, team captain William Calkins, Oscar Breeze, and coach Sam Hoyt. The mascot and ball boy is Bell Coffee. (JF.)

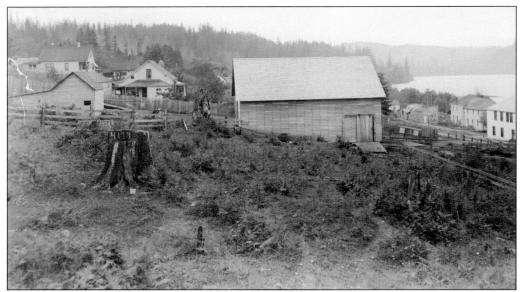

Looking to the south of Big Lake around 1912, standing timber has yet to be harvested. Stumps across the foreground show how recently the area was cleared. The business community around Lafayette Street is pictured with some residences on the hill at left and the hotel, saloon, and boardinghouse at lower right. (JF.)

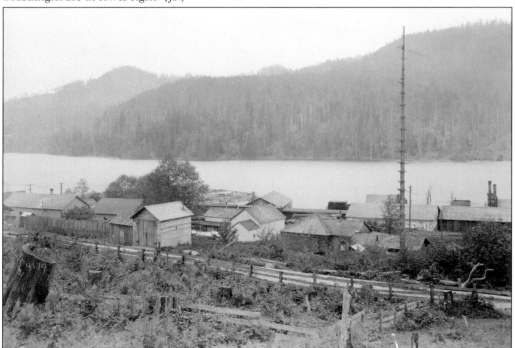

In this photograph, taken looking southwest across Big Lake, the south end of the mill and support facilities fill the foreground. The single-lane road that would eventually become State Route 9 can be seen as a thin white line along the rail fence. Across the lake, many of the old-growth trees still remain standing while logs float on the lake prior to entering the mill. (JF.)

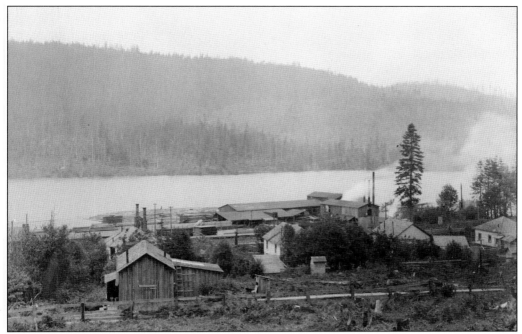

The main body of the Nelson-Neal Lumber Company mill can be seen as well as a few residences. Steam is rising from the drying kilns. The mill had its own generating motors and pumps. The small town counted some 250 residents with a post office, store, school, and boardinghouse. (JF.)

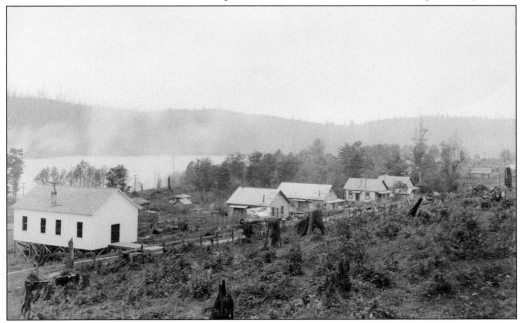

Company houses face a county lane in this c. 1912 northwest view. The mill provided some housing for working families. Single men lived at the boardinghouse or in numerous shacks around the community. Stumps remain throughout the area from the old growth removed in the previous decade. (JF.)

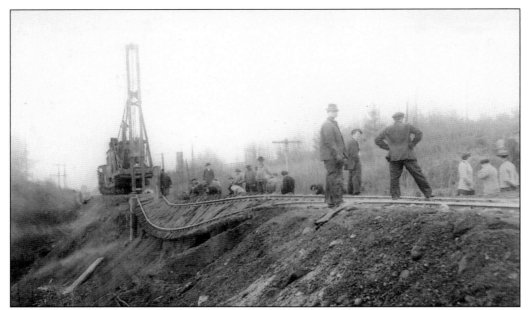

Travel and shipping via the Northern Pacific Railroad came to an abrupt halt when a slide occurred at Montborne in February 1914. There was no train in the vicinity at the time and therefore no injuries. Repair of the railway began immediately, and in a short time, travel and shipping began again. (BLHS.)

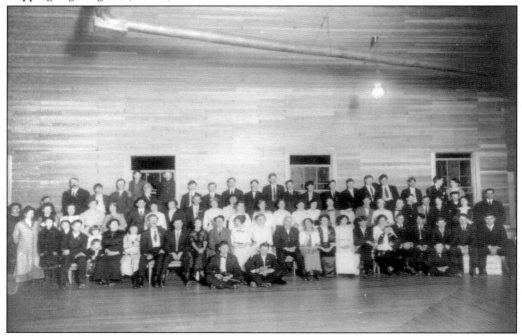

Women who were concerned about the destructive power of alcohol and the problems it was causing their families and society had organized the Woman's Christian Temperance Union (WCTU). Many area residents and community members gathered in the WCTU hall at Montborne to hold their meetings around 1915. Church services and dances were also held at the hall. (BLHS.)

Walter J. Deierlein Sr., left, talks with an unidentified man beside the railroad tracks looking up Lafayette Street past the boardinghouse around 1915. Walter was Judge Jack Deierlein's father. The family home still exists today around the sharp corner at the top of the hill. The Deierlein home later became home to the Sherman Prather family. (Courtesy of Alice Deierlein Nelson.)

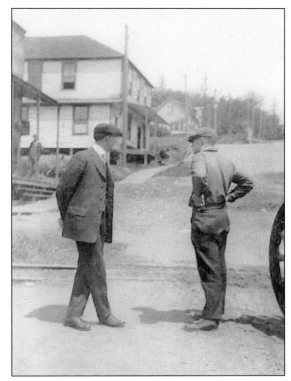

Roscoe Waechter is standing on the upper boardwalk of the hotel and saloon that replaced the original hotel and boardinghouse around 1915. The boardinghouse is seen to the north and across Lafayette Street behind Waechter. Roscoe Waechter's father, Henry Waechter, directed the building and setting up of the Nelson-Neal Lumber Company mill. (Courtesy of Lyle Archer.)

Inez Calkins captured slices of life with her Brownie camera. Life was pretty good for the teenager living at Montborne in the 1920s. The mill and small town were in full swing. Ball games and dances were common. She was asked when she first started going to dances and replied, "At the age of two or three I guess, the whole family went." (JF.)

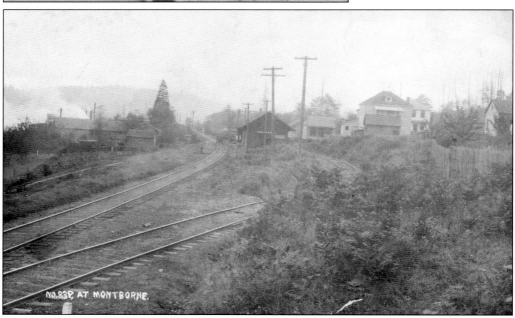

NO.839 AT MONTBORNE.

A nostalgic view of the railroad station, railroad siding, and the town of Montborne is seen on this popular postcard from the 1920s. The original hotel, long gone at the time of this photograph, had been replaced by the newer hotel and saloon to the right of the railroad station, with the boardinghouse behind it to the right. (JF.)

A cleanup crew works near the head saw and carriage. Logs would be secured to the carriage (behind the man on the left) and moved back and forth on tracks as the head saw cut off successive slices. The blade was removed daily for sharpening. All cutting blades throughout the mill would be sharpened daily and spares kept ready. (BLHS.)

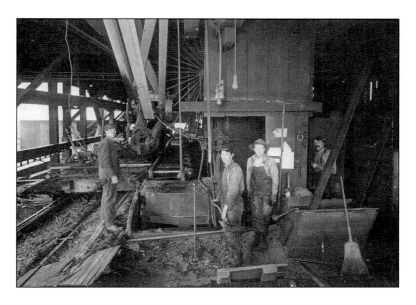

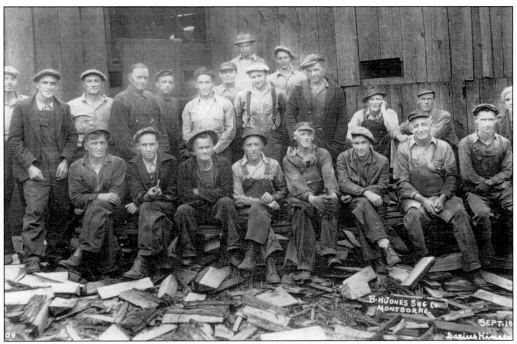

Following a period of fires and company losses, the Nelson-Neal Lumber Company closed, selling in 1926 to the Montborne Lumber Company. In 1930, Montborne Lumber Company also went out of business following damage to its Heisler locomotive and a forest fire taking out the railroad. B.H. Jones turned the mill's remains into a shingle mill in 1931, and the mill continued to operate into the 1950s. (Darius Kinsey photograph; BLHS.)

Montborne's first liquor license was issued on July 15, 1890, presumably for the original hotel. In this c. 1920 photograph, men strike a pose on the steps of the saloon and pool hall, which was located on the south side of Lafayette Street. Prohibition lasted from 1920 to 1933. (Courtesy of Skagit County Historical Museum, Ed Marlow Collection.)

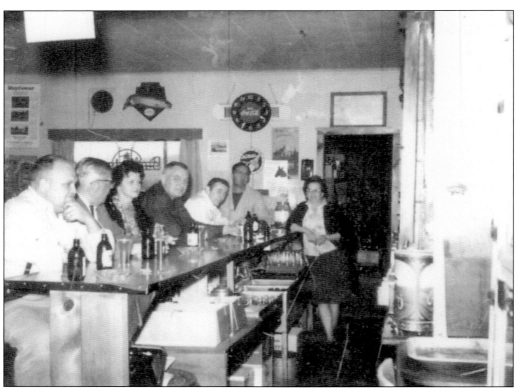

Dorothy Prather stands behind the bar of Sherm's Tavern, where patrons often gathered. Dorothy and her husband, Sherm, co-owned the tavern for several years. The tavern operated under several names: the Montborne Tavern, Jim's Tavern, Pat and Marty's Tavern, Sherm's Tavern, and Jo D's, and it is currently the Big Lake Bar and Grill, referred to by locals as the Big Lake Tavern. (Courtesy of Neal Prather.)

Mossington's Resort was a popular fishing resort from about 1934 through the 1950s. The resort was located on Big Lake at the sharp curve known as "Mossington's Corner" on State Road 9, just south of the current golf course. The resort had 12 cabins and 23 boats. Charles Mossington built most of the boats himself. Three of the cabins, called water cabins, were favorites because it was possible to fish from the cabin, swim, and keep a boat tied to the dock. In the summer of 1955, one of the water cabins caught fire, and the heat was so intense that it ignited the one next to it. They both burned to the water. Spot fires from the blowing cinders also started fires on the boathouse roof. (Both, JF.)

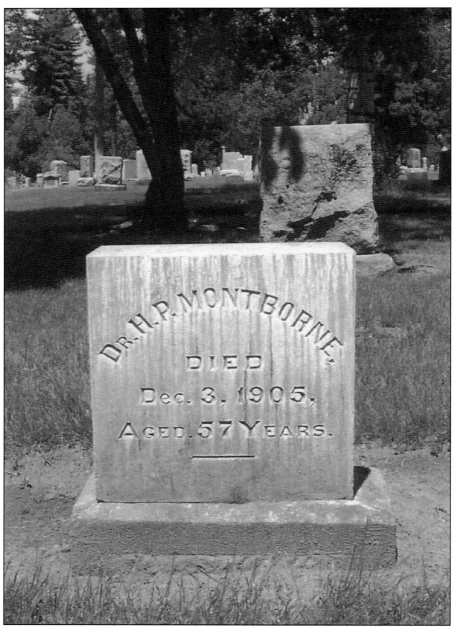

Dr. Hyacinthe P. Montborne was born in Paris, France, in 1848, educated there, and graduated from the University of Versailles. In 1880, he came to the United States, and in 1882, he moved to Washington. Dr. Montborne was a leader during the constructive days of early statehood and was the founder of Montborne. At that time, he was well to do, having numerous railroad and real estate interests. During the panic of 1893, his wealth was wiped out. His wife and two children died within a year after the loss of his fortune. He then left his dream to others and moved to Spokane. Although never an ostentatious giver, his charities benefited many sick and needy people. Dr. Montborne is buried at Greenwood Memorial Terrace Cemetery in Spokane, Washington. (Courtesy of Carolyn Rhodes.)

*Four*

# EHRLICH

In 1886, the Theiler family was the first to settle the south end of Big Lake. After the Seattle, Lake Shore & Eastern Railroad was constructed in 1890, mill towns sprang up along its route, and this area became known as Theiler's Spur. Frank Ehrlich of Seattle built a shingle mill there around 1894, and Theiler's Spur was renamed Ehrlich. Other settlers arrived, including the Wepplers in 1895, Frieschknechts in 1897, and the McInnises around 1898.

The rail line, along what is now State Route 9, was the main transportation route. Besides freight trains, there were two round-trip passenger trains daily, as well as a through-train from Seattle to Vancouver, British Columbia. Local children picked and sold wild blackberries to train crews for 50¢ a gallon.

Logging trains on railroad spurs brought cedar logs to Ehrlich's mill. Horse-drawn wagons on a tramway transported cedar from Sumner Lake near the Finn Settlement. A flume brought cedar shingle bolts from Lake McMurray and Holo. The L. Houghton Company, with an office in Ehrlich, logged the vicinity for several years. Nelson-Neal Lumber Company built a nearby logging camp around 1912.

School District No. 67 was organized in 1898. Teaching began in 1899, when a tiny school was built. The teacher taught eight grades with 10 to 30 pupils, depending on the population. Teachers often lived with local families.

The Hughes & Blake general store, built about 1910, carried everything from thread to cattle feed. When logging ended, most mill buildings were torn down, and the cookhouse became a dance hall and community center. Family members cleared land for farming. Farms became an important factor in providing subsistence for the community. Many of the men continued to work in the logging industry elsewhere. While the men worked away from home, the women and children often managed the farms. Descendants of the Weppler and McInnis families remain in Ehrlich, living and farming the lands settled by earlier generations.

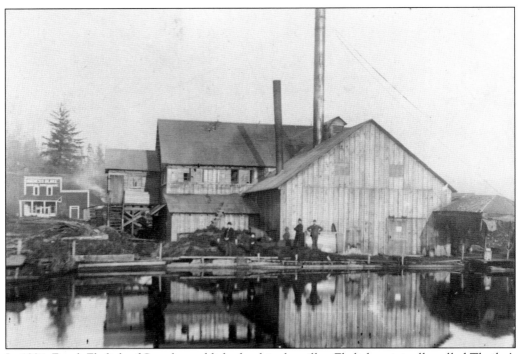

In 1894, Frank Ehrlich of Seattle established a shingle mill at Ehrlich, originally called Theiler's Spur. Local logging trains on railroad spurs brought cedar logs to the mill from nearby forests. Ehrlich and his wife sold the mill and their timberlands in 1902 to F.J. Pingry and J.D. Day, who continued the business. (AMX.)

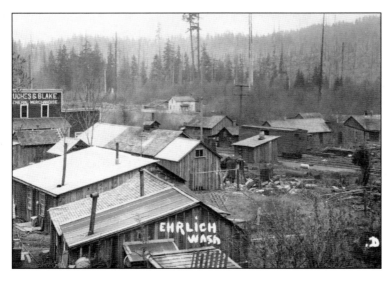

Ehrlich, seen about 1910, was once called Theiler's Spur. The Theiler family emigrated from Switzerland to LaConner in 1885, settling in this area in 1886. The railroad arrived in 1890, and Ehrlich established the shingle mill in 1894. The Hughes & Blake general store housed the post office, the train's ticket office, and the community's only telephone. (AMX.)

Emil Theiler poses with his Ehrlich friends in 1917. From left to right are (first row) Max Weppler and Arthur Dunlap; (second row) Emil Theiler, Kenneth McInnis, and Henry Weppler. Theiler had four siblings. He served in World War I and suffered lasting ill effects but ably managed the family farm once home. (AMX.)

Oline Sophie Bufladen Nersten married Samuel Thorsen Nersten in 1911. Emigrating from Norway, they came to Ehrlich in 1913 and bought Arthur Dunlap's home. The Nerstens had three children, Marie, Thor, and Hans Arthur. Other families arriving a short time later and staying many years in the Ehrlich area were Beal, Cohen, Crisp, Lindquist, McKinney, Niznik, Reece, Simmons, Smith, Stewart, and Wymer. (Courtesy of Carol Nersten.)

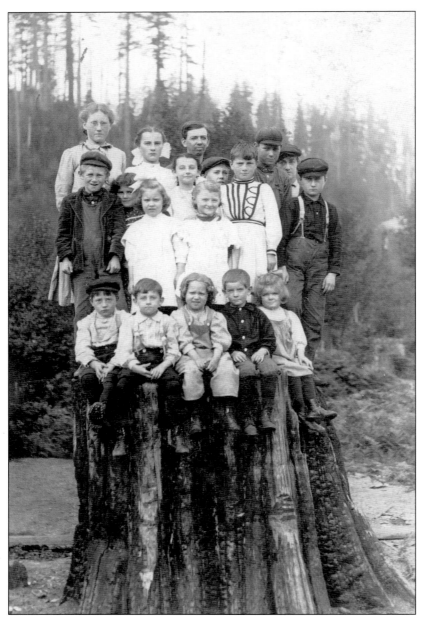

These students represent the eight grades taught at Ehrlich School in 1908. They pose on a cedar stump adjacent to the second school. From left to right are (first row) Frank Weppler, Lant Platner, June Schumaker, Max Vaughn, and Velma Vaughn; (second row) Kenneth McInnis, Arland McInnis, Gladys Schumaker, Hazel Platner, Lelia Hegg, Max Weppler, Helen McInnis, and Henry Weppler; (third row) Violet McInnis, Elnora Weppler, L.D. Vaughn (teacher), Bert McInnis, and Emil Theiler. Many early photographs were taken of people on the stumps of old large trees to indicate the size and for photographic interest. This stump had been burned in an earlier forest fire. In the summer of 1914, smoke was so thick from lightning-caused fires and accidental logging fires that the growth of crops was negatively impacted. That summer the sun was seen as a dim orange-red ball. (AMX.)

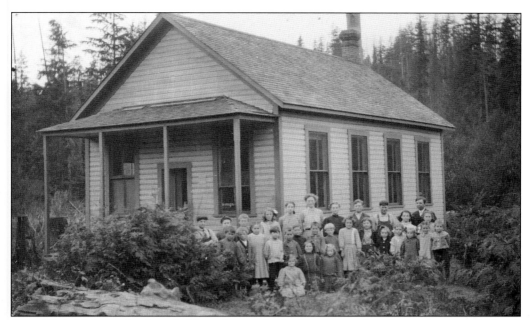

Since Ehrlich's first school was held in a home, this building was referred to as the second school. Built around 1904, all eight grades were taught in one classroom with a wood-burning stove. This school later became a residence. Four of the area's original families were represented: Theiler, Weppler, Frieschknecht, and McInnis. The teacher was L.D. Vaughn. (AMX.)

Ehrlich's third school, built in 1914, was across Schoolhouse Creek from the second school. It also included all eight grades but was almost twice the size of the second school. The bell in the tower signaled the beginning of the school day and the end of recess. Eventually, logging declined, the school closed, and it became a home. Remaining students transferred to Big Lake School. (AMX.)

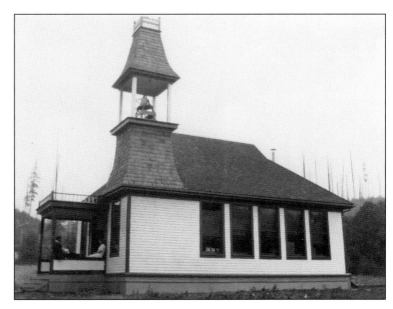

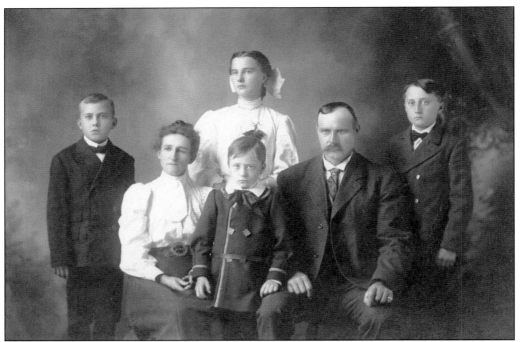

Johann Weppler came to the United States in the late 1880s. He married Rosa Stutzer Hanke in Chicago in 1893. They homesteaded at the Finn Settlement, moving to Ehrlich around 1895. From left to right are Max, Rosa, Elenora (standing in back), Frank, Johann, and Henry. Johann worked for Pingry-Day Mill. He served on Ehrlich's school board, and in 1911, he became Ehrlich's postmaster, a post he held for many years. (Courtesy of John Henry Weppler.)

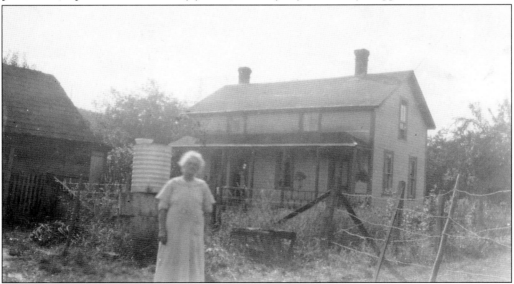

Rosa Weppler is facing north in front of the family home and barn around 1935. Using his horses, a Case tractor, and working by hand, Johann Weppler cleared his land for farming as time allowed. The hardworking family milked dairy cows, harvested oats, and grew hay for their livestock. (Courtesy of John Henry Weppler.)

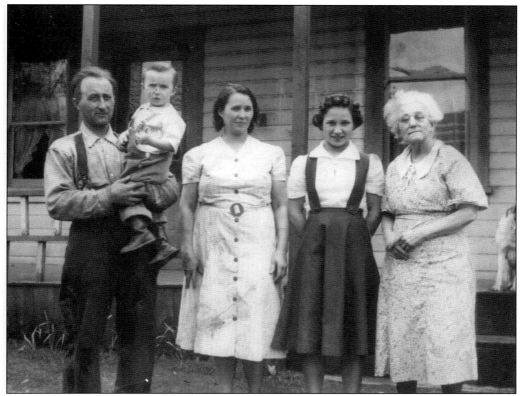

Henry Weppler's family stands by their original house about 1940. From left to right are Henry, John Henry, Ida Weppler, Velma Crisp (John's half sister), and Rosa Weppler. Typical of many farm families, the women helped as needed with land clearing and farming. Rosa Weppler raised calves. She and the other ladies had big gardens and preserved the fruits and vegetables they grew. (Courtesy of John Henry Weppler.)

Weppler family members are threshing oats in the early 1940s at a mechanical thresher and conveyor. The grain was directed into burlap bags, later sewn shut by hand. Oat straw was released onto a conveyor and later stacked; it was used for livestock bedding. The majority of the oats was used for livestock feed on the farm, and some was in family meals. (Courtesy of John Henry Weppler.)

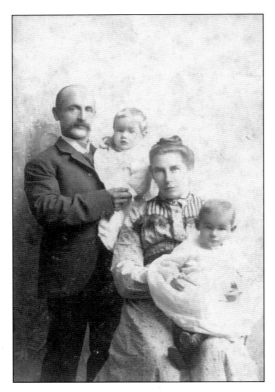

Albert and Anna Widmer Frieschknecht are pictured with their twins, Albert (left) and William (right), around 1904. Frieschknecht, a German, came from Switzerland in 1897 and settled at Ehrlich. In 1901, Anna traveled from Switzerland to marry Albert. They stayed in a house on Theiler property until their land was cleared. Later, they had three other children, Sophia, Ida, and Henry Fisher. The family name was changed to Fisher in 1919. (Courtesy of Robert Fisher.)

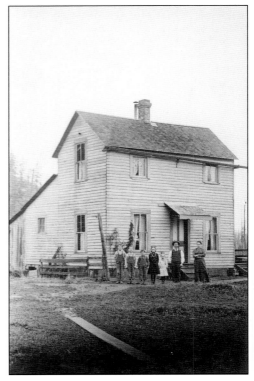

The Frieschknecht house and family are shown at Ehrlich in December 1912. From left to right are Albert, William, Henry, Sophia, Ida, Albert, and Anna. Besides farming, Frieschknecht had a saloon near Ehrlich from about 1908 to 1920. While at the saloon, he was robbed. He shot at the man, but the bullet lodged in the door jam; the robber shot back and missed. (Courtesy of Robert Fisher.)

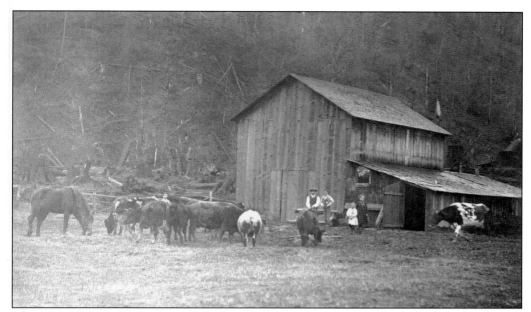

The Frieschknecht barn, pictured about 1912, was located near the house. Four of the family members are in this picture. They had a few milk cows and a couple of horses. Fresh logging can be seen in the background. Together, with the use of horses, the family cleared the land by hand. Cleared ground was needed for buildings, gardens, and sunlight. (Courtesy of Robert Fisher.)

Marvin and Robert Fisher, pictured around 1934, are the children of William and Clara Ruth Nordal Fisher. Marvin Fisher married Audrey Anderson (Anderson Blueberries), and they had four children, Randy, Beverly, Steven, and Marvin. Robert Fisher married Gloria JoAnne Busha and had four children, Jerome, Chad, Todd, and Veonne. Robert Fisher and his wife started Fisher Construction in the mid-1950s. (Courtesy of Robert Fisher.)

Charles McInnis and Marinda Elizabeth Michael McInnis were married in 1892. McInnis, part Scottish, was born in Canada. Coming from Ballard, they moved to Ehrlich around 1898 and bought 100 acres in 1901. He worked in the Ehrlich and Blanchard mills and with the railroad. He was also a school board director for Ehrlich and Sedro-Woolley High School; she was a housewife and farmer. (AMX.)

The historic McInnis home, built in 1902, remains just north of Ehrlich. Barns and other outbuildings were added to the property. The six children slept in two rooms upstairs. Charles McInnis bought a wood stove, carrying it home on his back from Mount Vernon. Marinda McInnis named her farming business High Rock Dairy. (AMX.)

The early 1900s saw the finishing of the silo and storage of hay at the McInnis barn. The horses were crucial help clearing farmland of the logs and stumps that covered the property. The McInnis family farmed small crops and had a dairy. A scythe was used to cut hay until machinery could be purchased affordably. Below, in the early 1900s, two-horse teams were necessities on the 100-acre McInnis farm. They pulled farm equipment used for planting and harvesting crops. McInnis horses were well cared for and treated as pets by the children who rode them. (Both, AMX.)

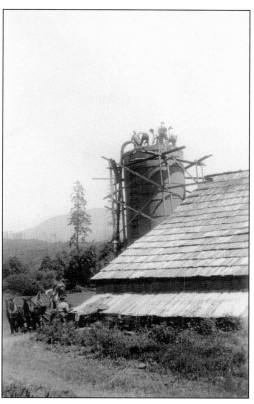

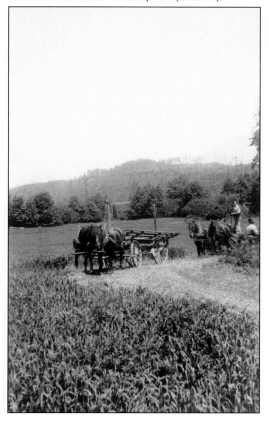

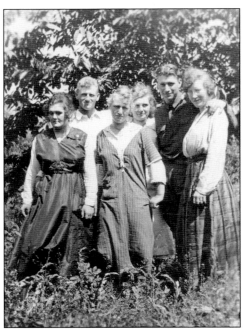

The McInnis children, from left to right, Arland, Kenneth, Thelma, Helen, Bert, and Violet, are pictured at home in 1918. Bert became a train engineer and Kenneth a logger in Alaska and Washington. Helen and Thelma started as "flunkies" or waitresses in logging camps. Helen graduated business school. Thelma and Arland became nurses. Violet helped on the farm and served on Ehrlich's school board. The girls acquired the family farmland. (AMX.)

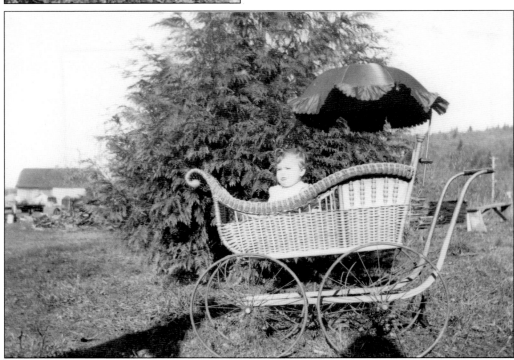

The McInnis baby buggy arrived in Ehrlich by train in 1899, when Charles McInnis's daughter Helen was a year old. It was made of wicker and had a dark clover-pink umbrella. Its big wheels made travel easier along pathways to the local Hughes & Blake store. In 1947, Andrea Elizabeth, Helen McInnis Millward's daughter, sits in the buggy on the Millward farm. (Courtesy of Elizabeth Xaver Stewart.)

## Five

# BIG LAKE

Homer H. Shrewsbury and W.G. McLain bought the machinery left from the first Montborne mill in 1898 and set up a new mill at the north end of Big Lake. In 1899, they sold their mill to Parker Brothers, which owned two shingle mills. They moved their other mills to Big Lake. In 1900, Joseph Day purchased the mill from Parker Brothers, thus beginning the Day Lumber Company.

J.C. Wixson and C.C. Bronson of Rhinelander, Wisconsin, became the major stockholders of the Day Lumber Company in 1902. The company made many improvements to the plant, and by 1910, the Day Lumber Company was a growing and productive concern. The little town of Big Lake was in its heyday just before World War I. Business was good, and there were steady jobs for men anxious to work.

The town of Big Lake was owned by the Day Lumber Company. The town had a depot, company store, post office, hotel, boardinghouse, town hall, reading room, church, and hospital, as well as many storage buildings, bunkhouses, and company houses for the mill workers' families. The Day Lumber Company had its own money, called tin money, that was used to pay workers and make purchases at the company store.

Two fires destroyed a major part of the town of Big Lake. The first fire was in 1923, and the second and more destructive fire was in 1925. As in many other mill towns of that time, the 1923 and 1925 fires changed the course of Big Lake's history and the lives of the people who lived there.

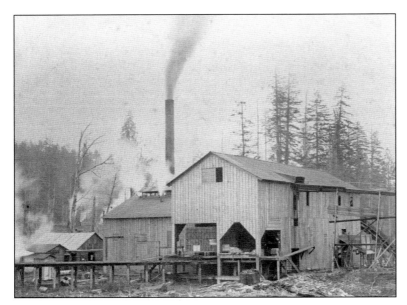

In 1898, Shrewsbury and McLain owned their original sawmill on Big Lake. They had purchased the remains of Dr. Montborne's burned mill and moved the machinery to the northwest side of the lake. Later, it became the nucleus for the Parker Brothers Mill, followed by the Day Lumber Company. Jack Splane and A.E. Hendrickson constructed most of the mill buildings. (MHH.)

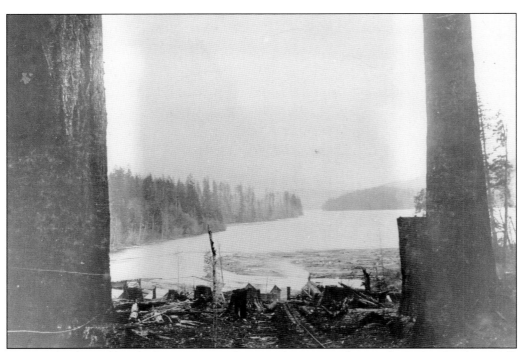

Large cedar, fir, and hemlock trees grew right up to the water's edge. At the Parker Brothers Mill, located at the north end of the lake, the landing donkey pulled the logs from the boom into the mill. In 1899, the mill owners thought that there were 100 years' worth of trees to be cut and harvested, but 25 years later, they were all gone. (Courtesy of Ed Marlow.)

Darius Kinsey assembled this collage in 1899 as an advertisement for the Parker Brothers Mill. The collage shows the different segments of the mill: the horses that were used to bring in the logs, the shingle mill, cedar to symbolize the trees used to make the shingles, and the sawmill. (Courtesy of Whatcom Museum.)

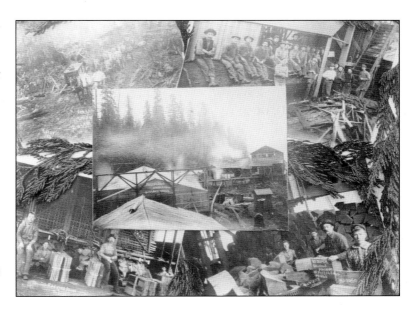

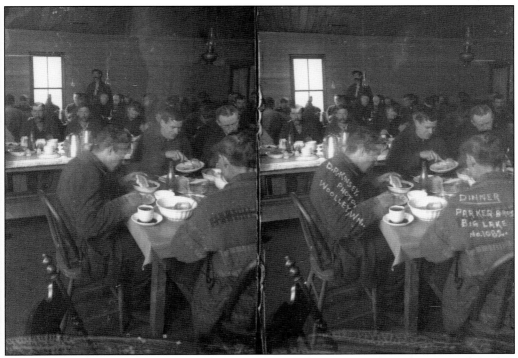

A stereoscopic photograph shows the mill workers and loggers sitting down for a typical meal in 1899. The men were fed well because healthy workers made good workers. They are eating from standard logging camp dishware. The double image photograph card was designed to be inserted into a handheld viewer, creating a three-dimensional effect. (Darius Kinsey photograph; courtesy of Whatcom Museum.)

# J. C. WIXSON, CIVIC LEADER OF SKAGIT COUNTY DIES AT SEDRO-WOOLLEY—WAS BURIED TUESDAY

J. C. Wixson, for many years one of the most prominent industrial, business and political leaders of Skagit County, died Saturday in Sedro - Woolley aged seventy-nine. He had been ill many months and was confined to his room in the hotel, which bears his name and which he built in 1907 to replace the old Osterman hotel.

Funeral services were held Tuesday afternoon in the Lemley Mortuary chapel at Sedro-Woolley. Burial took place in the Union cemetery. Rev. J. K. Griffiths of the Presbyterian church of that city officiated and oldtime friends acted as pall bearers.

J. C. Wixson was born October 5, 1856, at Port Hurnon, Mich. Here he spent the formative period of his life. When still a young man he went to Rhinelander, Wis., and engaged in lumbering. In 1902 he came west with the late C. C. Bronson and located at Big Lake, where the two acquired an interest in the Day Lumber company, which they operated until 1923. After retiring from the lumber business Mr. Wixson devoted his time to a large farm in Eastern Washington and The First National Bank of Sedro-Woolley, now in process of liquidation.

During his active years Mr. Wixson took a leading part in Republican councils and was prominent in the Automobile and Good Roads associations. Besides his banking and land interests, he helped promote and finance a fruit cannery and several business buildings.

The survivors are the widow, Mrs. Bessie Wixson, who lives at Big Lake; her daughter, Mrs. Ray Clark of Mount Vernon; a sister, Mrs. Elizabeth Erwin, and Mrs. H. J. Nibbelink, a niece, of Sedro-Woolley.

J.C. Wixson was one of the main partners in the Day Lumber Company. He came from Rhinelander, Wisconsin, with a reputation as a good manager. He liked the mill and surrounding area to look its best. Known as a rather stern businessman, Wixson also operated a bank and hotel in Sedro-Woolley. He lived on Knob Hill or Silk Stocking Row, the names given to the areas where mill managers had their homes. J.C. Wixson and C.C. Bronson bought out Joseph Day and became partners in the Day Lumber Company. Bronson operated the business end of the company from their Seattle office. He was a businessman and was well thought of in the community. In 1923, Bronson sold his shares to E.L. Conner. (Courtesy of the *Argus*.)

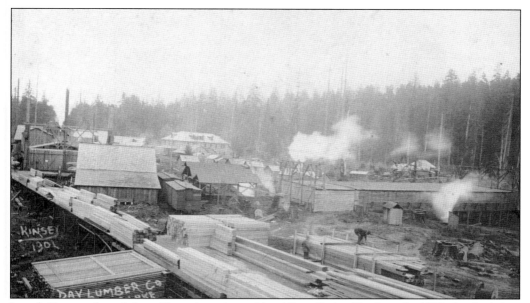

Joseph Day purchased the mill, equipment, and land from Parker Brothers. In 1901, the dry kilns, in long flat buildings on the right; the lumberyard; and the train coming from the Northern Pacific siding are shown in operation. The two-story building in the background is the boardinghouse. (Darius Kinsey photograph; MHH.)

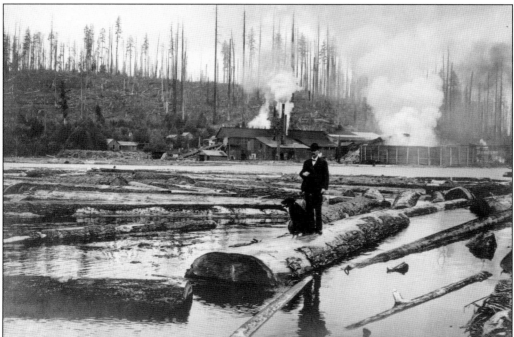

This early picture shows the sawmill on the west side of the lake around 1905. The small trees left on the hillside were considered too little to use. The large wooden container is where the sawdust was burned. A worker was hired just to keep the wooden burner wet. J.C. Wixson, with his dog Dave, is standing on one of the large logs ready for the mill. (MHH.)

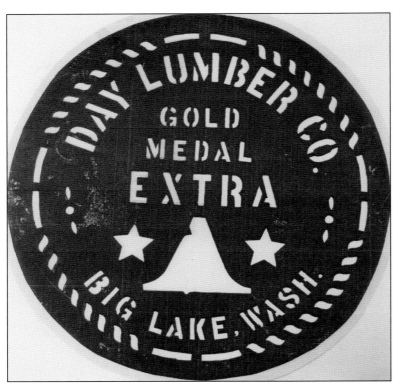

The Day Lumber Company stamp identified where the lumber was sawn. The company had several Big Lake stamps, as well as stamps for the Seattle plant. Big Lake lumber shipments sold to the East Coast were often stamped with Seattle stamps because the city of Seattle would be better recognized there. (BLHS.)

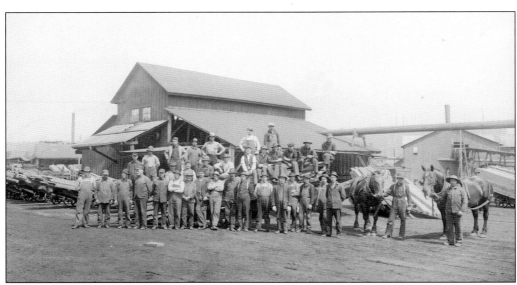

In the beginning, the Day Lumber Company used Percheron horses to bring logs to the mill and to move lumber and equipment throughout the plant; horses were used until 1906. A hog wood grinder ground leftover wood trimmings to a slushy pulp. The pulp was carried by endless conveyors and deposited in large boilers that helped furnish power and lighting to the different parts of the mill and the town. (BLHS.)

J.C. Wixson (left) is standing in front of the large water tank at the mill along with a Mr. Ward (right) during an unusually cold winter. The icicles hanging from the leaking water tank made for an extraordinary photographic opportunity. Maurice Splane, the mill superintendent, had placed the water tank in the lumberyard to protect the mill from fire. (BLHS.)

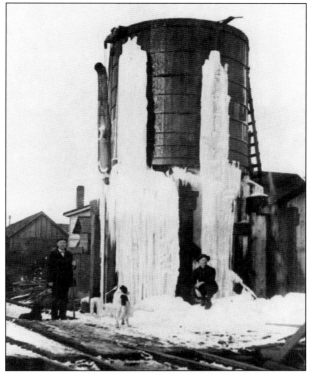

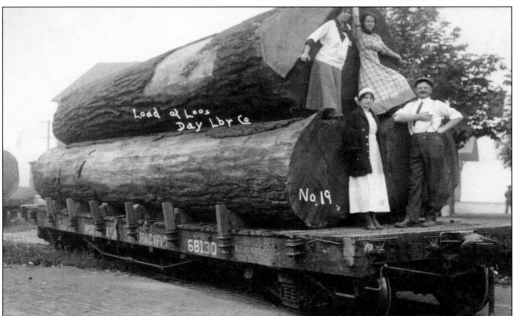

When timber close to the mill became scarce, the company built tracks east of Big Lake. Rail flatcars transported the logs to the lake. Many of the logs were six to eight feet in diameter. Teachers sometimes took their students on field trips to see the very large logs. Some logs were so large that they were dynamited in order to get them in the sawmill. (BLHS.)

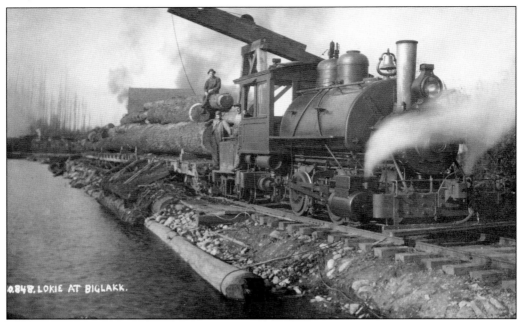

A Heisler locomotive (seen above), nicknamed the "Goat," was one of several locomotives owned by the Day Lumber Company and operated by engineer James Barringer (sitting on the log). In the photograph below, Mr. Layhee, a fireman, watches as a load of logs is dumped into the lake, creating an enormous splash. In the background, smoke is rising from the sawdust burner at the mill. As the forests close to the lake were depleted, the trees were harvested from the surrounding hills. Flumes were built to slide the logs down to the lake. The flume was greased so the newly cut logs could slide into the water. They were gathered into a log boom that was pulled to the mill by a tugboat. (Both, BLHS.)

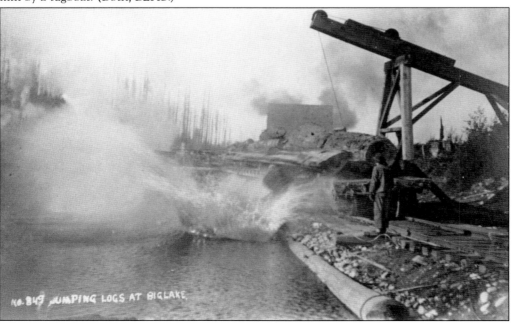

Mill workers frequently posed in front of one of the company buildings. These pictures were put on inexpensive postcards, which made it easier for the men to purchase them. A selection of photographs for sale is posted on the wall behind the men. In the second row the fifth person from left is Albert Lockwood, followed by, from left to right, Bill Carson, Sky Koski, and Charles Carlson. (Darius Kinsey photograph; courtesy of Louise Komen.)

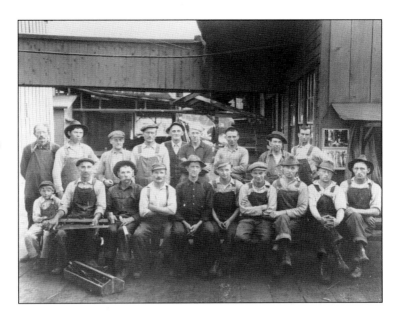

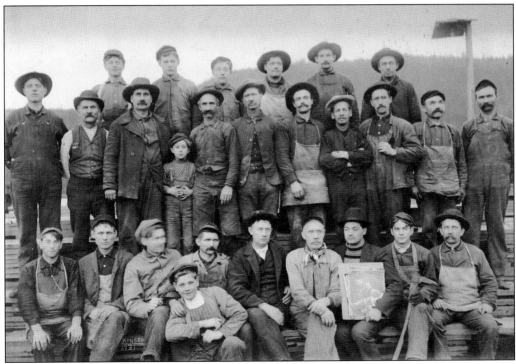

Darius Kinsey shot many logging and mill photographs from the Big Lake Valley. He used a large format camera that enabled him to create extremely detailed images. The photographs were printed by his wife, Tabitha, and sold to workers. The man in the front row is holding a Kinsey print of Fall City Doc, a Snohomish medicine man. (Darius Kinsey photograph; courtesy of Lyle Archer.)

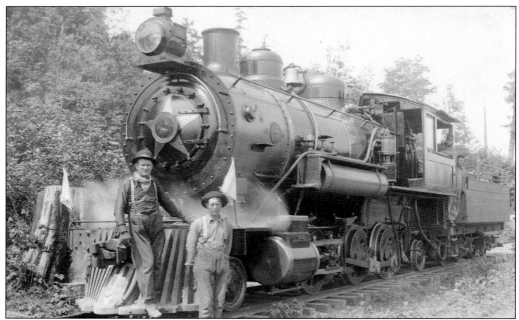

The *Two Spot* was one of several train engines that the Day Lumber Company used about 1915 to bring logs from the hills to the mill. The engineer on this train was James Barringer (in cab), with Pete Osborne (left) and the assistant woods boss, a Mr. Gilpin (right). The train hauled more than logs, as many injured loggers were taken to the company hospital via the logging train. (MHH.)

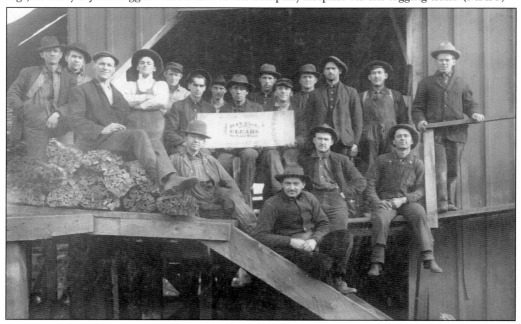

A crew of shingle weavers, including bolt cutters, knot sawyers, and shingle packers, proudly displays a shingle stamped "Extra Clear" at the mill in Big Lake. In 1908, the mill could produce approximately 250,000 shingles a day, along with thousands of cedar and fir laths. (Darius Kinsey photograph; courtesy of Big Lake Grocery collection.)

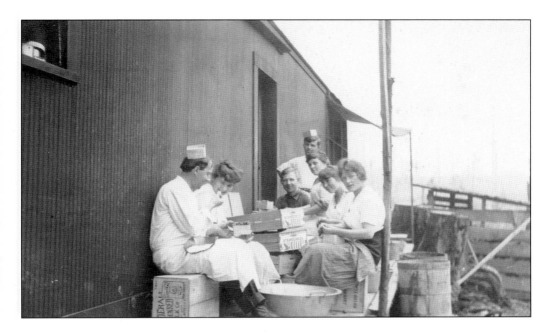

Camp cars were brought in by rail and were set onto sidings. The buildings had sleeping facilities, showers, cookhouses, dining rooms, and electricity. Cooks were hired to prepare several large meals a day for the workers. Waitresses, known as flunkies, helped prepare, serve, and cleanup after the meals; Alvan Johnson (second from left) and Bertha Luraas (third from right) are two of the flunkies sorting strawberries for the next meal. Once the area had been logged off, the camps could be moved by rail to the next site. (Both, MHH.)

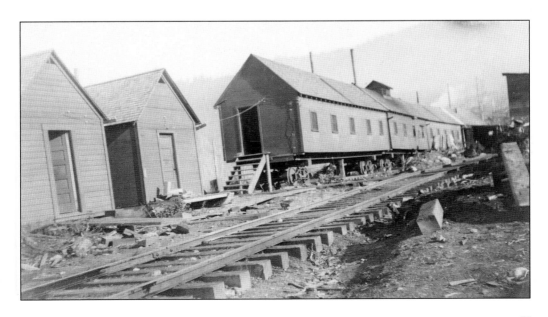

Ernie Pederson was a young boy going fishing in 1906 when he spotted a photographer at the Northern Pacific depot. The station manager, Archie Griffin, called the young boy over to join him, a Mr. Cottell, Charlie ?, and a Mr. Stevenson for the photograph. Archie Griffin gave the boy his hat to wear for the special moment. (BLHS.)

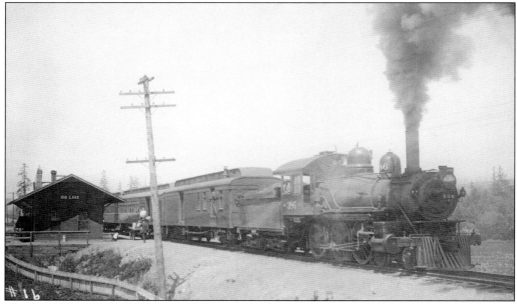

The Northern Pacific line operated the railroad depot in 1906. Passenger trains ran north and south twice a day. The Day Lumber Company store fence is shown along with the bridge over the swamp that was eventually filled in with sawdust. Electricity was provided by the mill and only worked when the mill was running. (BLHS.)

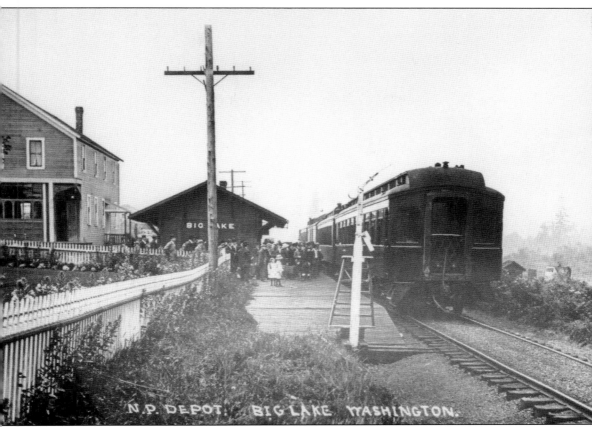

The northbound Northern Pacific train stopped at the Big Lake depot. The residents of Big Lake and surrounding communities shopped, banked, and did much of their business in Sedro-Woolley. It was easier to ride the train to Sedro-Woolley than to go by horse and wagon to Mount Vernon. Young boys would meet the train and get the *Post-Intelligencer* or *Seattle Times* to sell to the workers. John B. LaChapelle's hotel and saloon are on the left. The saloon was torn down during Prohibition. The picket fencing and attractive flowers bordered the property of the Day Lumber Company. The company offices, the post office, and the company store were a short walk from the depot. LaChapelle hid pennies in a large sand-filled barrel for the kids to uncover; they would buy candy at the store with the money they found. (BLHS.)

The Day Lumber Company Mercantile, pictured about 1905, was located alongside the company boardinghouse. A wooden plank sidewalk connected the two buildings. A railroad spur led to the mill and down the east side of the lake. The boardinghouse burned in 1905; a new boardinghouse was built on the same site. One man was reported to have died in the fire. (BLHS.)

The second boardinghouse was built on the same site following the 1905 fire. The boardinghouse accommodated about 75 men. The first floor held a reading and lounging room, plus tables and benches for playing cards; a court trial was even held there. A 1910 newspaper article said the company hired an excellent cook to prepare hearty meals for the men. This boardinghouse burned down in 1925. (BLHS.)

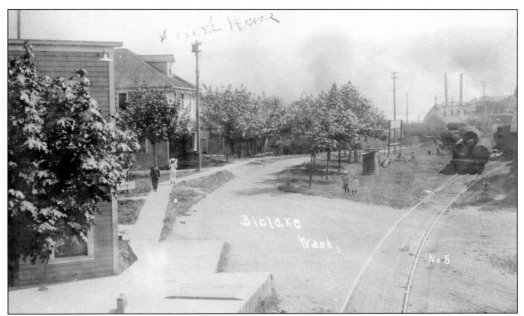

A boardwalk extended the length of the town connecting the company store, the boardinghouse, Mrs. Wixson's Reading Room, and the workers' cottages beside the creek. Maple trees were planted throughout the town and along the road to the mill. A spur from Northern Pacific's main line extended to the mill and down the lakeside to the log dump. (BLHS.)

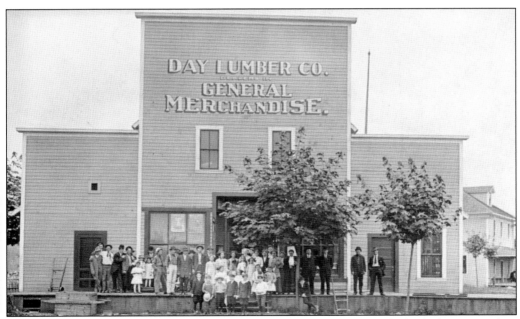

A second floor and new front were added to the company store by 1910. It had a fresh meat market, an ice cream parlor, groceries, clothing, and household items. The post office was on the west side of the building, and company offices were located on the south side. (BLHS.)

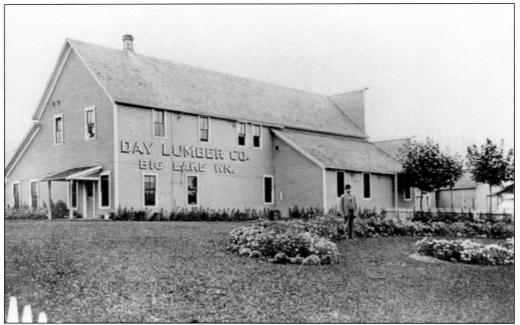

The Day Lumber Company was doing a bustling business by 1910, and it had updated several of its buildings. J.C. Wixson is standing in front of the new addition to the Day Lumber Company Mercantile. A second floor was added to the original building. Flower beds and large-leaf maple trees were added to create a pleasant setting in the logging community. (BLHS.)

The post office was located on the side of the company store in 1910. J.C. Wixson (right) and an unidentified friend are standing in front of the boardinghouse. The car was one of the first in Big Lake and belonged to Wixson. The large-leaf maple trees that lined the original road through the company town are still standing. (MHH.)

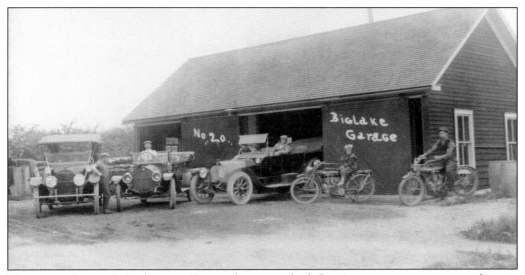

There were few roads in the area. Cars and motorcycles belonging to management were kept in the company garage. One car owner was known to walk two miles downhill from his house to get to his car, go for a short ride, then walk the two miles back home. This building was later covered with briars until being torn down in the 1960s. (BLHS.)

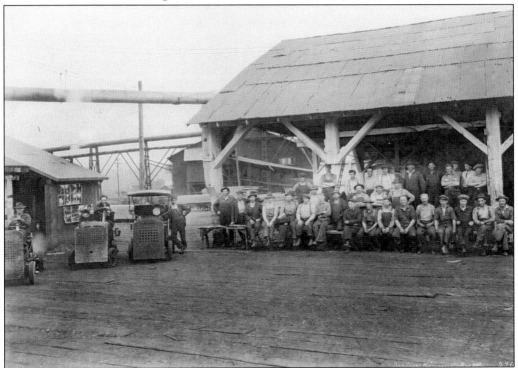

Jitneys were used to move lumber and equipment through the mill and yard in 1925. Horsepower had taken on a new meaning. Pipes running through the plant carried ground sawdust to be burned as fuel for steam engines. A large fire broke out in 1925, but the workers were able to save much of the plant, which continued to operate until 1927. (Darius Kinsey photograph; BLHS.)

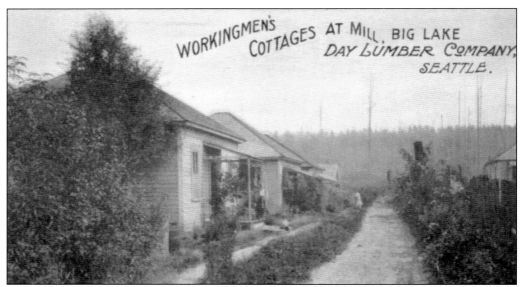

Postcards were sent out across the country advertising work. The back of this 1909 card reads, "Quality counts in Lumber and Shingles. To secure quality it is necessary to have competent, contented workmen. We aim to provide comfortable homes, pay good wages and obtain quality. We shall be pleased to hear from you. Day Lumber Company, Seattle, Washington." (MHH.)

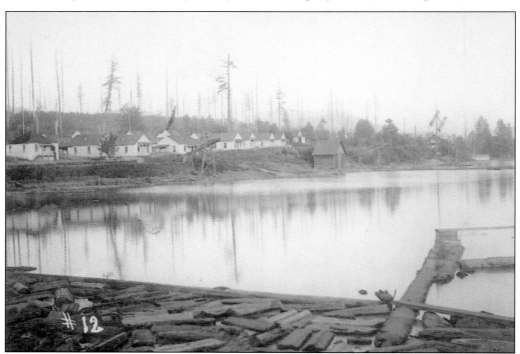

Facing the lake are some of the company houses built on Lakeview Boulevard. Logs waiting for milling float in the foreground. The small building at the water's edge is the company icehouse. Many of the winters were very cold; ice was cut from the lake in large chunks and stored in sawdust for spring and summer use. The company hospital is located to the south. (BLHS.)

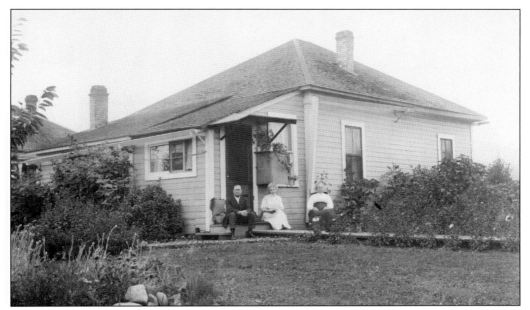

Walter Boyce and his wife are sitting with Elizabeth Jardine, mother of Annie Boyce, in front of a typical company house. Boyce was the postmaster at Big Lake. Johnny Vogel, who farmed much of the Day Lumber Company land, later occupied this house. Vogel worked for the company and was known as the "Grunt Man" or the "Bull Cook." (BLHS.)

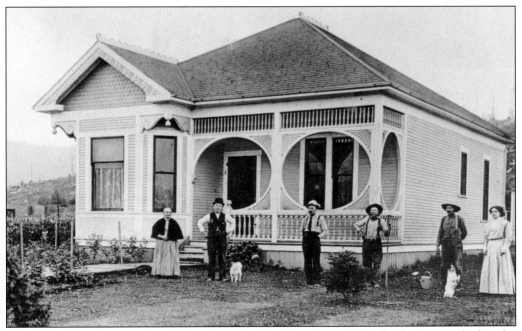

John B. LaChapelle, a native of Canada, arrived in Big Lake in 1899 after having worked in the timber industry in Wisconsin. He successfully operated the hotel and saloon in Big Lake until 1912. The home he built for his wife, Nora Anderson, was a local showpiece known for its fine architectural detail. This home still exists. (Courtesy of Audrey Von Ray Waldrop.)

Gathering on the front porch of a classic company house, the Frank Wanzer family with Jack Splane (second row, left) and his wife (second row, right) are ready for a day of fishing around 1910. Wanzer was the head sawmill filer for the Day Lumber Company. Splane was the head mill manager for a long time; he knew every detail about the mill and was an excellent administrator. (MHH.)

In 1908, boys cleared briars and leveled a large sawdust pile to make their playfield. They formed the first company baseball team in Big Lake. From left to right are (first row) Charles Komen, Dewey Watson, Uno Lundstrom, Otto Lytle, and Willis Lytle; (second row) Norman Lough, Ervin Kimble, Art Barringer, and Ed Gilpin. (MMH.)

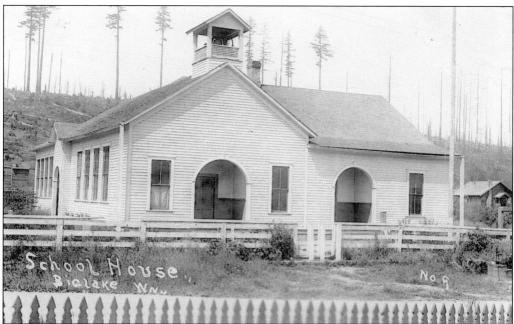

Big Lake had a one-room schoolhouse in 1901. In 1906, a second room was added, and by 1923, the school consisted of four rooms. This building had a hitching post and an outdoor water pump. There were houses behind the school in an area known as Tin Can Alley. This school burned down in late August 1923, and the students thought that meant no school, but school was held in the church and in the teacher's cottage. In 1921, Anne Sandhigh taught third and fourth grade classes. She married Martin Benson and substituted at the school for many years. Below is a 1917 picture of students at Big Lake School. When the photographers came to town, they could count on a crowd showing up to see if they could get their pictures taken. (Both, BLHS.)

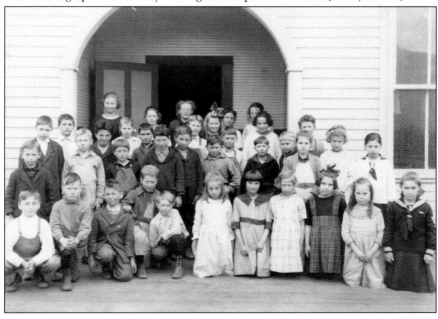

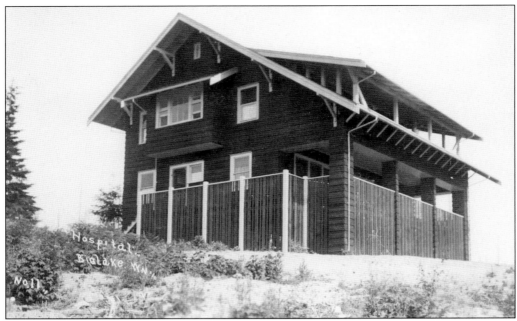

Logging was a dangerous occupation. Work in a sawmill or on a steam railroad was dangerous also; serious accidents and dismemberments were frequent. Without prompt treatment, many died. When the Day Lumber Company built a small but modern hospital in 1909 at Big Lake, it was a blessing for the entire community. Many company hospitals would offer medical treatment only to their employees, but the staff at Big Lake cared for the families as well, including delivering babies. J.C. Wixson was proud of the hospital because of its cleanliness and modern equipment. (Both, MHH.)

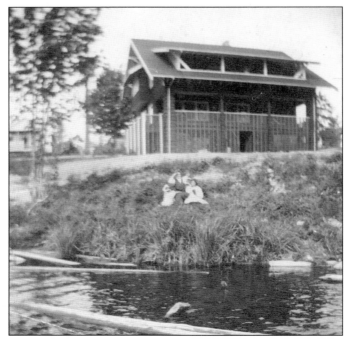

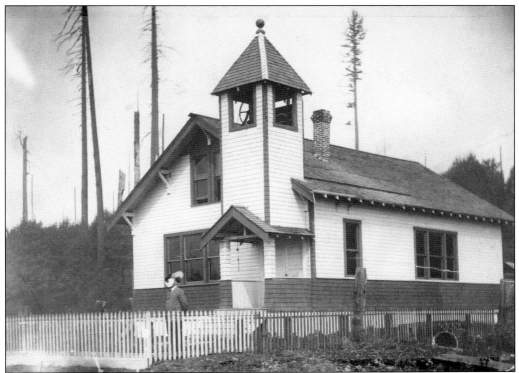

Local carpenters and community members built the Big Lake Community Church in 1917. Several different denominations used the building until its conversion to a private home. Rev. James Barringer pastored this church at different times over the years. The bell was removed and placed in the new church in 1959. Below, children of the community are being honored on Children's Day with banners and streamers. The chairs were typical school chairs of that day, and two of them remain in the newer church. The benches were made of solid cedar from local trees milled at the Day Lumber Company mill. The pulpit was hand made by Arthur Tripp, one of the mill carpenters. (Both, MHH.)

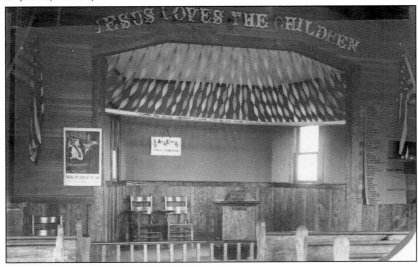

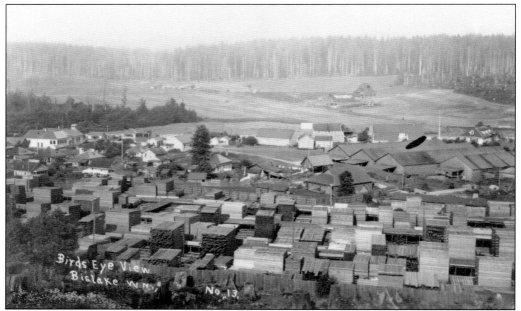

The mill and the lumberyard anchored the town of Big Lake in 1910 as the town grew to add homes and a school. Orchards and gardens were planted to feed the growing community. The company farm flourished on freshly cleared land, adding pastures for the growing dairy herd. (Courtesy of Whatcom Museum, Wes Gannaway Collection.)

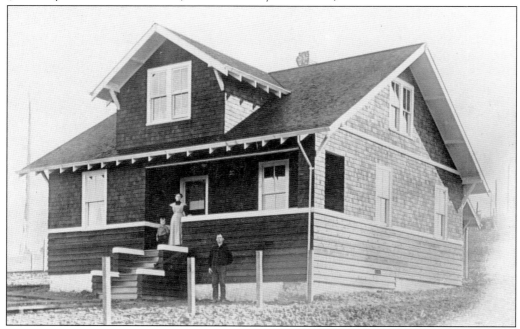

Company carpenters built the first company ranch house in 1910. The Roberson family is standing in front of the house. A walkway behind the house led to a small building that was used as a creamery, managed by Florence Roberson. A herd of 23 cows provided milk, butter, and cream for the company store. This house burned down, and a new one was built on the same site. (MHH.)

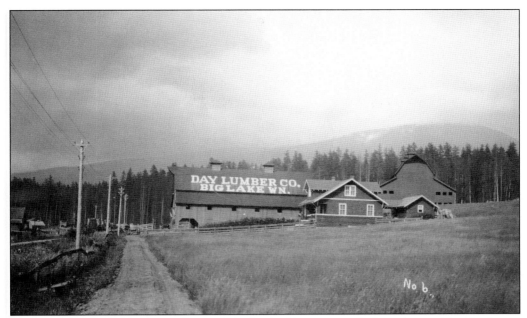

The Day Lumber Company raised most of the food sold in its store. It cleared several hundred acres of land and raised cows, sheep, chickens, and grass for hay. It built two barns. The Day Lumber Company name painted on the first barn was there long after the company was gone. (BLHS.)

Frank and Florence Roberson, their son Ralph, and a hired helper (left) stand in front of the barn with a team of Percherons. Horses were used both in the mill and on the farm to help clear land of stumps and slash, plow fields, and do much of the heavy work. The Robersons managed the farm for several years. (MHH.)

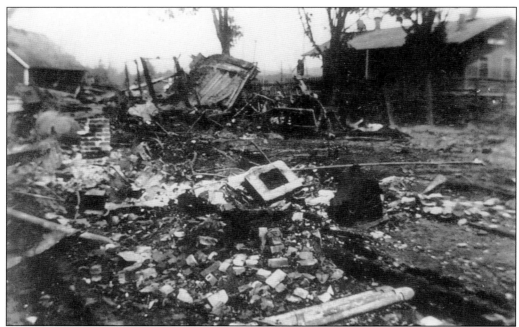

Business was not going well in the late summer of 1925. Three years earlier, J.C. Wixson had sold his share of the company to Frank Day. The morning of August 13, fires started throughout the mill. Later, containers of kerosene and gasoline were found in the sawmill; water hoses had been cut near the hydrant. The company store is pictured above, and a fire appeared to have been set underneath the counter. The depot is in the background. While the company employees were rushing to put out fires, new ones were flaring up all over the plant. Firefighters came from Mount Vernon to help. William Engle, a former watchman, died in the fire. Pots, pans, a hot water tank, and large ovens are shown in the ruins of the fire as Charlotte Meyers examines the debris. (Both, courtesy of Dyrk Meyers.)

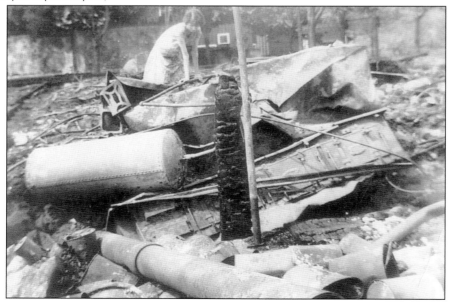

*Six*

# THE FINN SETTLEMENT

The Finn Settlement, located in Skagit County, Washington, is a small community on Lake Cavanaugh Road. The first families arrived around 1891 and took up homesteads and timber claims in the deep woods several miles northeast of McMurray, bringing in their possessions on pack horses or their own backs over a difficult trail. The settlement's original name was Pleasant Valley, and though it later became known as the Finn Settlement, not all families were Finnish. The first homesteaders to proved their claims were Johann Weppler in 1895 and Charles Granstrom, Ole Holme, and Johannes Sumner, all in 1899. Later families were Kittila, Koski, Latva, Lombola, Hill, Nurmi, Uitto, Maki, Balchelor, Markham, and Currit.

Though the Finnish-speaking people were isolated, they were very active in community affairs, and they had a voting precinct, school, and roads. They built their houses of split cedar and supported their families by cutting shingle bolts, sending them down flumes along Pilchuck Creek to a shingle mill at Pilchuck or hauling them over trail from Lake Sumner to Ehrlich. In 1895, they built a road from McMurray, the county paying them for their labor.

In 1921, an English Lumber Company rail line reached the Finn Settlement and established two logging camps, Camp 7 and Camp 8, near the settlement. The men and some women found work in the camps. As timber was harvested and English Lumber Company moved deeper into the woods to Lake Cavanaugh, the workers rode the "mulligan" car on the railroad to and from camp. In 1944, Puget Sound Pulp and Timber acquired English Lumber Company, and it later dispensed with the rail operations to haul logs to log dumps and mills by trucks.

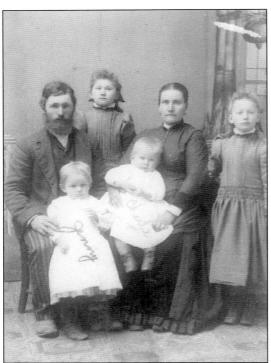

Charles and Maria Granstrom arrived in Skagit County with their family in 1893 and homesteaded a claim in the Finn Settlement. He was very industrious; he became road supervisor and helped build a wagon road from Lake McMurray to Lake Cavanaugh. As a farmer, Granstrom grew four varieties of tobacco in addition to other crops and harvested timber. The fourth generation still lives on part of the original homestead. (Courtesy of Mary Granstrom Buzzell.)

A map detail from 1913 shows that various lumber companies largely owned the land, but settlers were beginning to establish new communities such as the Finn Settlement along Pilchuck Creek. The early families to settle in the Finn Settlement were Sumners, Kittila, Koski, Hendrickson, Lombolo, Waglund, Uitto, Lahti, Hill, Latva, Granstrom, Haurunen and Maki. (Courtesy of Julia Uitto Krieger.)

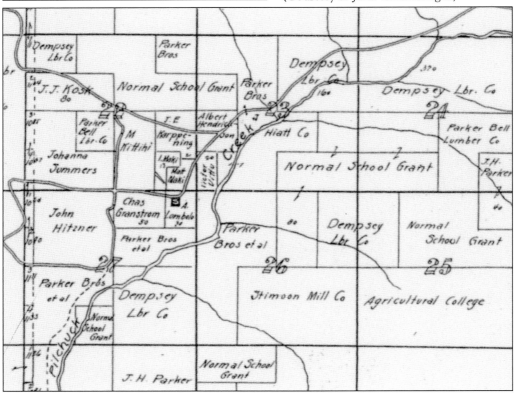

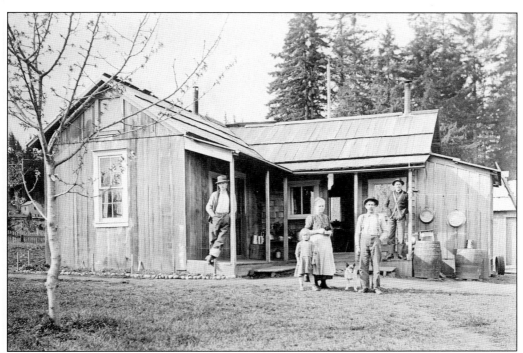

The first home of Victor and Otillia Lillbacka Uitto, pictured about 1915, was built entirely of hand-split cedar boards and shakes. On the left side of the porch is son Isaac Uitto, and on the right is William Maki; in foreground are Victor and Otillia Uitto with daughter Sara. Uitto's first trip to America was in 1893, and he returned in 1903; his family followed, Otillia Uitto in 1913 and his children, John (19), Isaac (17), and Sara (4), in 1915. At right is a portrait of the growing Uitto family in the early 1940s. From left to right are (first row) Julia and Ida Uitto; (second row) Otillia and Victor Uitto and Eileen Koskela; (third row) Sara Uitto Koskela and Bill and Irvin Uitto; (fourth row) John Uitto, Oscar Koskela, Olga Wilen Uitto, and Ormand Koskela; (fifth row) Isaac Uitto. (Above, courtesy of Julia Uitto Krieger; right, courtesy of Ida Uitto Jensen.)

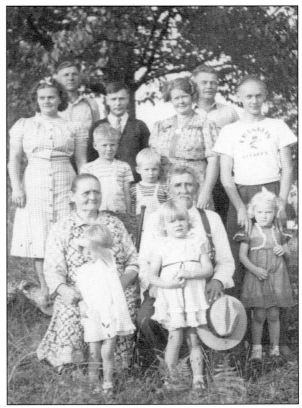

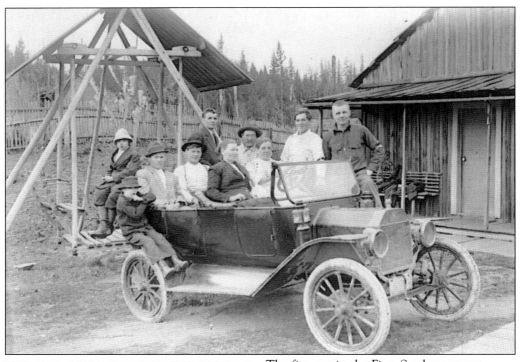

The first car in the Finn Settlement was this 1915 Model T, parked in front of the Isaac Waglund home. The home and the swing are made of hand-split cedar boards from local trees. From left to right in the car are Albert Lombolo, Ford Pierson, Vernice Ranta, Elmer Berry, an unidentified friend, Lizze Hendrickson, Isaac Waglund, Mary Waglund, Helmer Waglund, and a Mr. Lindbloom. (Courtesy of Edwin Kittila.)

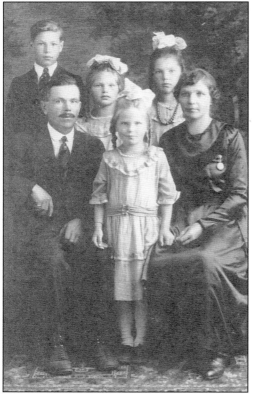

Matt and Lydia Haurunen and their children, William, Elma, Aili, and Lydia, were one of the earliest families arriving in the Finn Settlement. They came to take up timber claims. The Timber Culture Act, passed by Congress in 1873, was part of the Homestead Act and allowed homesteaders to acquire another 160 acres of land if they planted trees on 40 acres. (Courtesy of Eino Hill.)

Four generations of the Granstrom family are pictured in the early 1940s sitting on the porch of the Kangas home. From left to right are (first row) Mary and Janet Granstrom; (second row) Jack Granstrom, Lola Prather Granstrom, and Maria Granstrom Kangas. The patriarch of the family, Charles Granstrom, applied for and obtained a land patent from the federal government in 1898. His daughter Clara was the first birth to take place in the Finn Settlement. Below, the Granstrom family celebrates Matt and Maria Alatalo-Granstrom Kangas's 25th wedding anniversary in 1940. Helping them celebrate were, from left to right, Jack Granstrom, Joe Dodson, Elmer Kittila, Isaac Uitto, Matt Kangas, Maria Kangas, Joe Granstrom, Rosie Currit, Mary Granstrom, Roberta Granstrom, and the Nurmi girls; the others are unidentified. (Above, courtesy of Mary Granstrom Buzzell; below, courtesy of David Granstrom.)

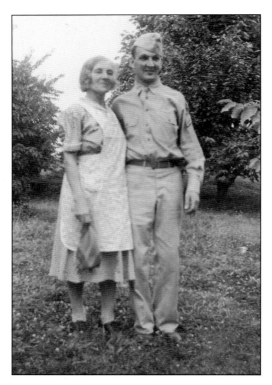

Johannes Sumner, a Norwegian immigrant, led a group of settlers into an area on the banks of Pilchuck Creek in the 1890s. Mike and Alma Hill were one of those families. Mike Hill passed away in 1942, and not long after, his son Eino, posing with Alma, enlisted in the Army and became an airplane mechanic. (Courtesy of Julia Uitto Krieger.)

The Currit family, Lucien "Shorty," Rosetta "Rosie," their sons Charles and Paul, and daughter Alvena, arrived in the Finn Settlement in 1937. Daughters Rosetta Maria and Rosa Lee were born after their move to the Finn Settlement. Lucien Currit came to work in the logging industry. Though not of Finnish descent, the family blended in well with their Finnish neighbors. (Courtesy of Alvena Currit Johnson.)

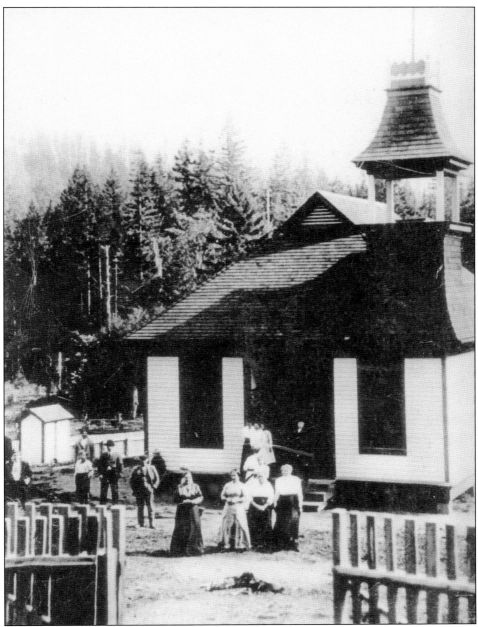

School first started in 1894 as Cavanaugh No. 61 with 11 children and John Tieman as school district clerk. The first schoolhouse existed between 1896 and 1915. In 1908, Charles and Maria Granstrom deeded land to the school district. In 1915, Sam Arnold of McMurray built the Finn Settlement School for Skagit County School District No. 61. Grades one through eight were taught, and teachers stayed at the Kittilas' home until a teacher's cottage was built across the road from the schoolhouse. In 1915, as the school population grew, a new schoolhouse and teacher's cottage were built. When the student population fell to less than six in 1935, the children were driven to Bryant School in Snohomish County. Around 1940, a road was built from the settlement to Montborne as part of a WPA project, and the children were bussed to Big Lake School. (BLHS.)

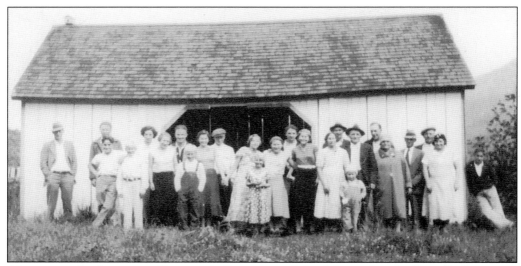

Above is a school picnic at Cavanaugh Community School, located in the Finn Settlement in 1934. Included are (first row) Art Granstrom, Joe Granstrom (leaning), Lina Latva (in black skirt), Millie Markham (the next girl), Helja Latva (in white blouse), Nina Nurmi (in black skirt), and Eino Hill; (second row) Matt and Hilja Latva, Maria and Matti Kangas, Lola Granstrom, and Jack Granstrom (leaning on the wall far right); the others are unidentified. It was a requirement that the Finn Settlement School should have at least seven students. In 1939, the teacher, Ethel Ingman, below, brought her daughter to school to make quota. Pictured are Ethel Ingman, daughter Eloise, and students Jacqueline and Jeannine Olson; Charles, Paul, and Alvena Currit; and Bill Uitto. In 1940, the students were bussed to Big Lake and Sedro-Woolley. (Above, courtesy of Mildred Markham-Granstrom Billingsley; below, BLHS.)

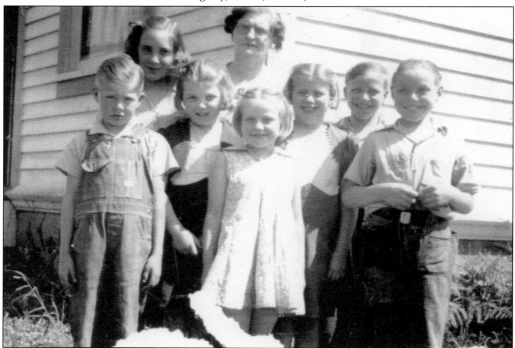

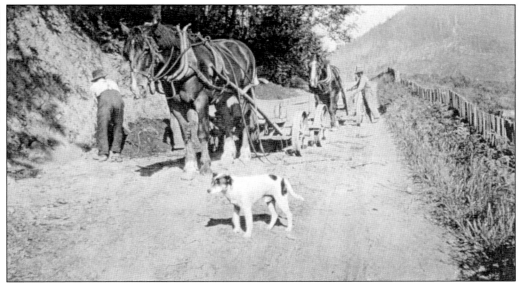

Construction of the road to the Finn Settlement from McMurray started in 1898 and was completed in 1900. Charles Granstrom was the road construction supervisor for District 47. It was his job to see that the roads were built and also to hire the workers. Horse-drawn wagons were used to remove all the soil. For many years, it was called the Granstrom Road. (BLHS.)

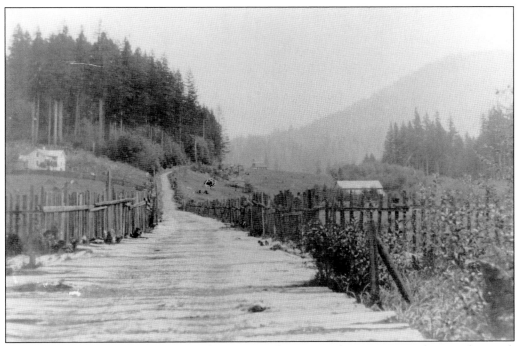

Around 1900, this section of road in the Finn Settlement was known as a corduroy or log road. It was made by placing logs perpendicular to the direction of the road over a low or swampy area. This was an improvement over impassable mud roads. At upper left is the Matt Kittila home, and at center right is the Granstrom barn. (Courtesy of Carol and Doug Richter.)

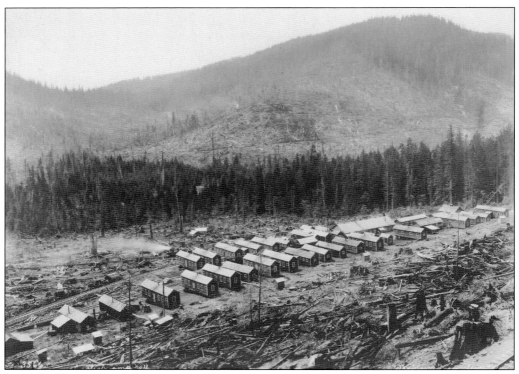

In 1902, Edward English began the English Logging Company, a name that would become synonymous with logging for the next 42 years. The company used trains that would collectively haul two and a half billion board feet of timber out of the woods. English logging camps were established at remote sites. Camp 11 was in the foothills a short distance from the Finn Settlement. These portable camps included a cookhouse, dining room, and bunkhouses. Latrines were built on site. After an area was logged off, the camp could be move to the next site. Jack Granstrom, one of the Finn Settlement men who worked at Camp 11, was a faller and choker. (Both, Darius Kinsey photograph; JF.)

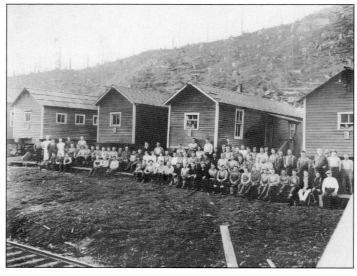

English Camp 10 was started in 1924 at the southeast end of Lake Cavanaugh and operated until 1929, when the area was logged off. The Finn Settlement men and women worked in these camps. A baseball field was often located in the center of the camp. Camp employees and supplies were transported in a railroad car called a mulligan. (Darius Kinsey photograph; BLHS.)

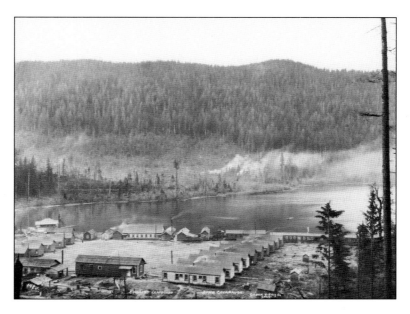

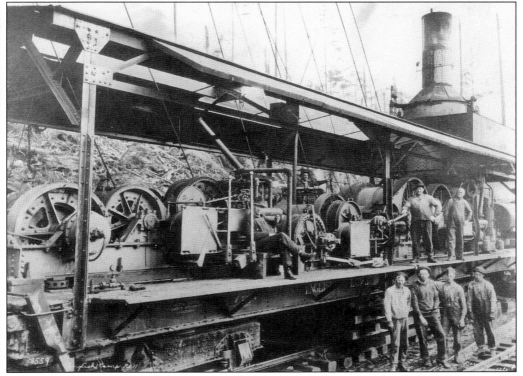

This skidder was used at English Camp 11, which operated between 1925 and 1936. The camp was located two and a half miles southwest of Lake Cavanaugh on Crane Creek. Because of its size, the skidder had train wheels, making it possible to move on rails to the next camp. The logging train hauled logs from the woods on the track next to the skidder. (Darius Kinsey photograph; courtesy of Whatcom Museum.)

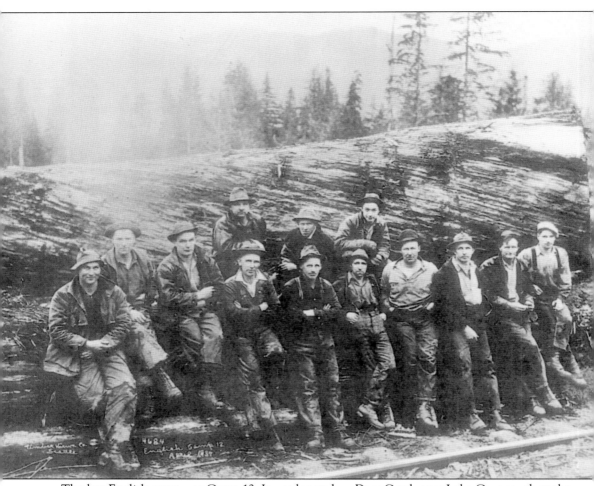

The last English camp was Camp 12. It was located on Deer Creek near Lake Cavanaugh at the end of the main line where logs were loaded onto the train. The company logged there from 1930 to 1944, when the operation was sold to Puget Sound Pulp and Timber Company. It operated the camp until 1952; identified Finn Settlement loggers are Albert Granstrom (first row, far right), John Uitto (second row, second from left), and Jack Granstrom (second row, far right). (Darius Kinsey photograph; BLHS.)

# Seven

# BAKER HEIGHTS

Families came to Baker Heights from all over. It was originally called Starvation Hill, until Esther Carlson thought of an appropriate name, as Mount Baker is easily seen to the northeast. This area of hills and dales also has Cultus Mountain directly east; Big Rock, Little Rock, and Skunk Rock as close neighbors; and the beginnings of the Big Lake Valley to the south.

An early landowner was a single woman, Emeline Smith, who lived in Whatcom County and filed on 160 acres in 1883. Sometime later, the Skagit Railway and Lumber Company logged the area. Trains brought logs to the nearby mills at Clear Lake and Big Lake.

The first settlers were Ben and Sofie Gunderson, followed by the Carlson brothers and the Johnson brothers, Algot and Swan. To document and preserve the names of other early arrivals, the families, in alphabetical order, were Benson, Dolittle, Engstrom, Fadeff, Foss, Fortner, Gould, Johnson (Otto and Jennie), Lindstrom, Lundeen, Nelson, Nilson, Olson, Peterson, Smith, Torgerson, Tower, and Yates.

People emigrated from Sweden, Norway, Russia, Canada, other countries, and various states. They came seeking opportunities that had been well publicized abroad. Bilingual homes were relatively common in Baker Heights.

The settlers encountered stumps and fallen logs left by logging. Families worked long hours to create a community. After clearing the land, they built a road in 1920 with hard labor and horses. Electricity arrived a few years later. Telephone service did, too, if one could afford the $1.50 a month. The first school was in the Benson home. A one-room school was built in 1918, followed by a two-room school in 1922.

Gertie Harker started delivering mail during World War I, progressing from riding horses to driving Studebakers during her 40-year career. She also shared local news and picked up items in town for those who could not get there.

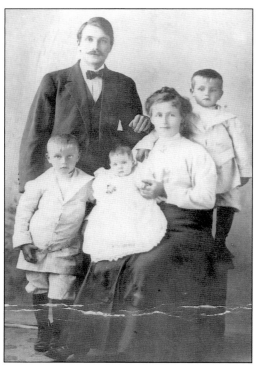

Anton Nelson came from Norway in 1906. His wife, Anna, and their boys joined him in 1909. Pictured in 1911 are Anton and Anna Nelson and their children, from left to right, Norman, Neva, and Peter. Nelson purchased 10 acres in 1912 sight unseen. After riding a stern-wheeler from Ballard to Mount Vernon and then driving two horse-drawn wagons, the family arrived in Baker Heights to settle on their property. (Courtesy of Richard Nelson.)

Anton Nelson built a three-room house and purchased another 20 acres. This steam donkey with winches and fueled by wood, pictured around 1912, was used on the Nelson homestead to move the numerous stumps left by logging, clearing the land for farming. Stumps were piled and burned, filling the region with smoke so thick one could scarcely see one's neighbors. (Courtesy of Richard Nelson.)

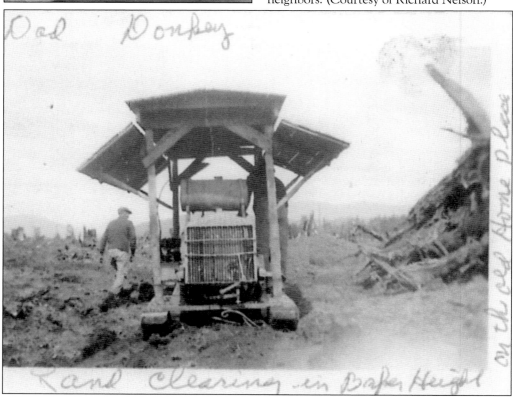

As the Nelsons settled into Baker Heights and the family grew, it was time to build a bigger home, seen above around 1928. The second house was Anna Nelson's dream house—it was bigger and had more rooms, plumbing, electricity, and a big radio. In 1940, below, the Nelsons gather for a family portrait. From left to right are (first row) Vincent, Anna, Anton, and Otto; (second row) Pete, Bernice, Richard, Neva, Art, Marie, and Norman. Anna Nelson birthed 10 children at home, including twin girls. One of the twins, Adeline, died shortly after birth. Anton walked to Mount Vernon to buy her small coffin, carrying it home on his shoulder, for burial on the farm. (Both, courtesy of Richard Nelson.)

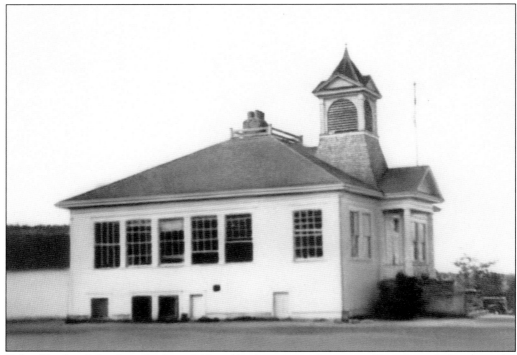

Baker Heights School was built in 1922 and had two large classrooms. First through fourth grades were taught in the east room, and fifth through eighth grades in the west room. Each side had its own cloakroom for coats, hats, and other items. The basement held the furnace and wood storage, a lunchroom with a sink and wood range, and restrooms. Approximately 60 children were enrolled in the 1920s and 1930s. Below is an early-1920s photograph of a Ford Model T school bus that picked up the Baker Heights students. Algot Carlson drove the first bus for the school. Other bus drivers were Orville Wilcox, August Schopf, Cliff Haynes, and George Marchant. (Both, courtesy of Dale Thompson.)

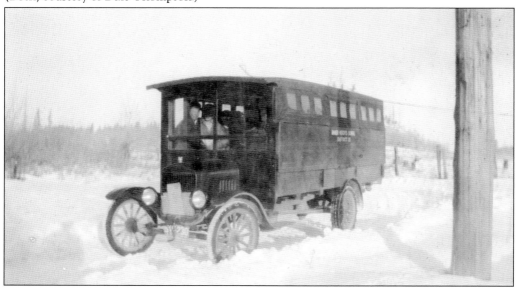

These students at Baker Heights School, through grade eight, stand for their student body photograph around 1939. As some students are unidentified, known family names are listed in alphabetical order: Brown, Buchanan, Carlson, Ellestad, Engstrom, Fadeff, Gaddis, Gilette, Gustavson, Hauenstein, Higgs, Johnson, Matterand, Post, Rood, Schopf, and Thompson. (Courtesy of Dale Thompson.)

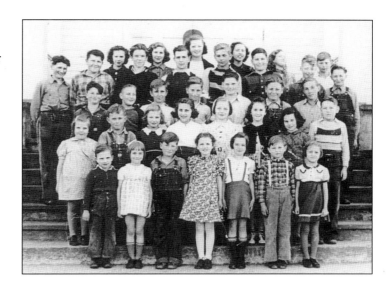

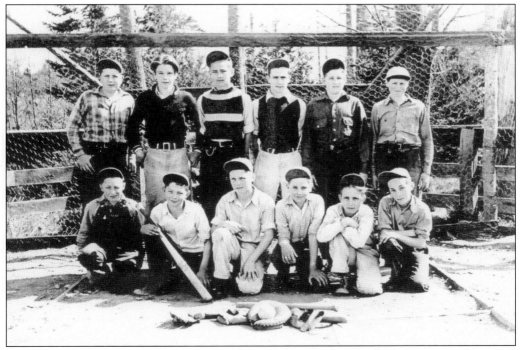

Like so many of the communities around them, Baker Heights also had an organized baseball team. This young team, organized in the mid-1930s, included, from left to right, (first row) Leland Hauenstein, Pete Fadeff, Earl Gaddis, Dale Thompson, Bob Brown, and John Johnson; (second row) David Gilette, Art Buchanan, Virgil Ellestad, Russell Brown, Floyd Schopf, and Marion Hauenstein. (Courtesy of Dale Thompson.)

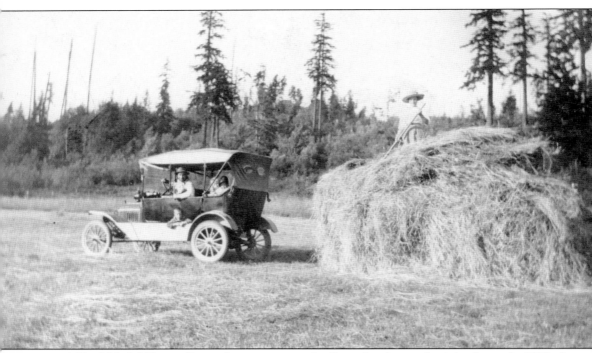

A Ford Model T is pulling a hay wagon on the Swan Lindstrom farm in the early 1920s. In order to "make hay while the sun shines," families utilized whatever equipment was available to complete the work, including horses, tractors, and sometimes the family car to pull the hay wagon. Neighbors cooperated, helping each other get their hay into the barns. Hay was hauled to the barn and stacked. Special hayforks, ropes, and pulleys powered by a tractor or horses hoisted the hay bundles into the loft of the barn. Once hay season was over, the livestock was turned out into the hay fields to graze any hay or grass left behind. This rotation of the fields allowed the grass in the pastured fields to grow for late summer or fall pasture. (Courtesy of Dale Thompson.)

*Eight*

# BIG ROCK

The Noo-qua-cha-mish Indians called a huge rock located east of Mount Vernon, Washington, Yud-was-ta. This was a sacred spot near the winter village of the tribe and has been referenced in a Native American legend.

Land on the east side of the big rock was found to be rich in clay by J.W. Knapp. The Knapp Brick and Tile Company of Everett, Washington, newly incorporated in 1911, bought 100 acres of this land for its new factory. This location, known as Tiloh, Washington, was between Big Lake and Clear Lake on the Northern Pacific Railway. The factory closed in 1944.

The little village of Tiloh, complete with a general store, disappeared after the factory's operation and closure. Once Tiloh was gone, the area simply became known as Big Rock.

A concrete bridge was constructed in 1920 over the Nookachamps Creek and the Northern Pacific Railroad. This bridge improved the connection between Big Lake and Clear Lake, much to the delight of travelers and those hauling freight.

John "Jake" Schopf bought land at Big Rock after losing his job as superintendent when fire destroyed the Big Lake mill in 1925. He proceeded to build a home and the Big Rock Service Station. The station has seen many owners over the years offering groceries, gas, a tavern, and a café.

Clear Lake, Big Lake, Baker Heights, and Mount Vernon continue to be tied together in this area where state roads intersect.

Big Rock appears to be shrouded in fog in this early-1900s postcard. The road to and from Mount Vernon was nothing more than a dirt trail. The Noo-qua-cha-mish Indians knew this bold pinnacle as a sacred spot highly regarded in their legends, naming it Yud-was-ta, which means "heart," or "of the heart," since it stood in the heart of the one-time Noo-qua-cha-mish homeland. (BLHS.)

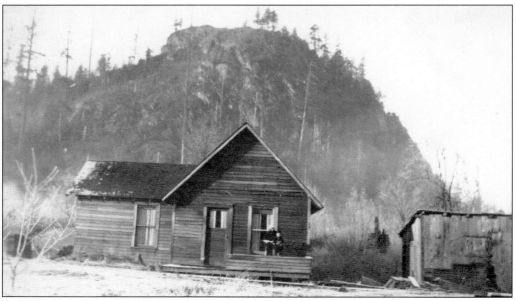

Blake Thompson's home sits near the base of Big Rock. The rock near an intersection of roads from Mount Vernon, Clear Lake, and Big Lake was located in an area known as Tiloh, Washington. The Knapp Brick and Tile Company constructed its factory at Tiloh, and J.W. Knapp built the home that Blake Thompson lived in. (Courtesy of Dale Thompson.)

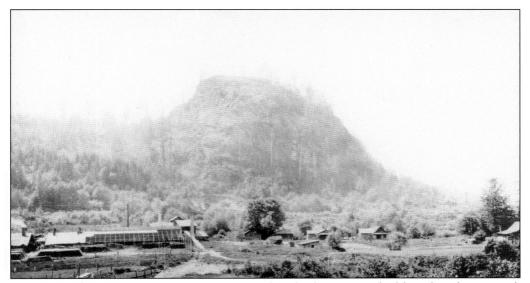

Seventy of the 100 acres owned by the Knapp Brick and Tile Company had first-class clay material. This material extended to a depth of nearly 40 feet. The factory, with a capacity of 25,000 bricks and 18,000 tiles a day, was equipped to make tile in sizes from four to eight inches in diameter. (Courtesy of Dale Thompson.)

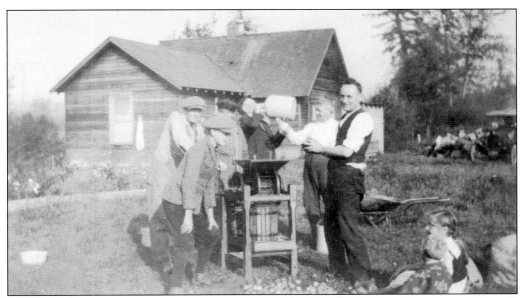

Blake Thompson, plant foreman of the Knapp Brick and Tile Company factory, stands with family and friends beside a cider press at his home. J.W. Knapp had several houses built for some of his employees. The little town of Tiloh was close by, complete with a general store. (Courtesy of Dale Thompson.)

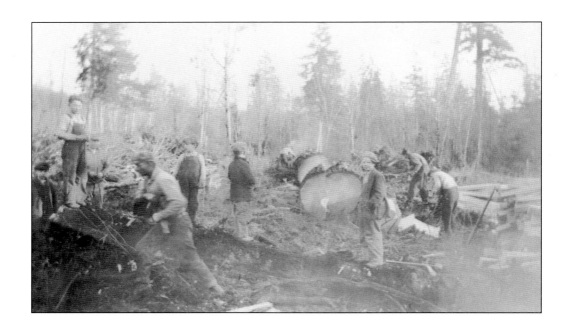

Many men were needed for woodcutting, as it was a big job providing enough wood to keep the kilns going at the brick and tile factory. The company had two Stewart-type brick kilns. They could be heated to 1,200 degrees and even as high as 1,750 degrees. Some local residents known to work at these kilns were Ray Robbins, Jim Potter, Roy Nickelson, Ed Monroe (a brick mason), Gilbert Anderson, Swan Lindstrom, and Blake Thompson (the plant foreman). The Knapp Brick and Tile Company was incorporated from 1911 to 1944 and located at Tiloh, Washington, the east side of Big Rock. J.W. Knapp was president and general manager. (Both, courtesy of Dale Thompson.)

J.W. "Judd" Knapp, on the left, tours the grounds of the factory with his wife. Local clay was dug by hand, brought to the kilns in clay cars, prepared, and fired. Large smoke stacks emerge from the building where the kilns were located. The center building was used to store the finished brick, tile, and pottery. (Courtesy of Dale Thompson.)

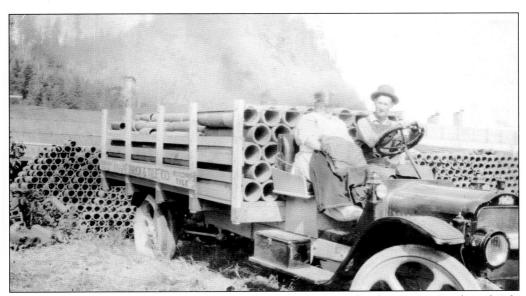

An early White flatbed truck was used for hauling products for the Knapp Brick and Tile Company. This particular load of drain tile was not up to the company's high standards and was called "seconds." Clay drain tiles were necessary in the Big Lake Valley to improve drainage in extremely wet soils. (BLHS.)

A snowy scene at Big Rock features the house J.W. Knapp constructed to demonstrate how building tile was laid for construction, followed by finishing tile and a coat stucco. Knapp also built several houses for factory employees and their families. (BLHS.)

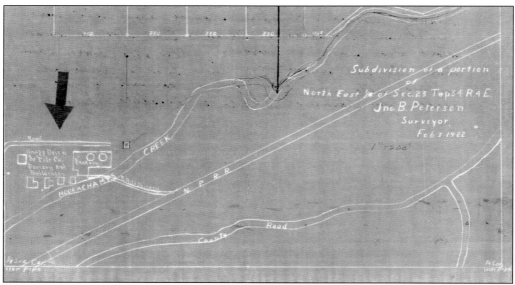

A subdivision was planned east of the brick and tile factory. This is a blueprint drawing dated February 1922 by Jno. B. Peterson, surveyor, showing the location of the factory, railroad, county road, Nookachamps Creek, and the planned subdivision. The arrow highlights the factory buildings and their individual locations. (BLHS.)

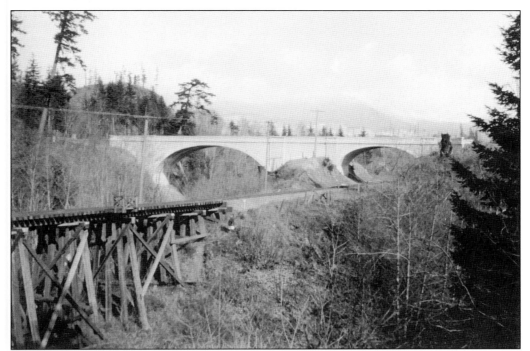

The concrete bridge at Big Rock was built in 1920 over the railroad and Nookachamps Creek. It was an important link in transportation between Clear Lake, Big Lake, and Mount Vernon. The bridge, still in use on State Road 9, has a width of 20 feet; it is quite narrow by today's standards. The total length of the bridge is just over 230 feet. (BLHS.)

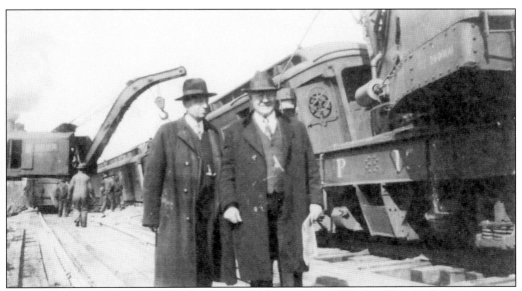

A train wreck near Big Rock injured one crewmember and proved fatal to Tom Anderson, a veteran conductor. The accident happened due to a defective truck under the tender as the Northern Pacific passenger train was on its way to Wickersham to pick up Civilian Conservation Corps boys who were being mustered out. The men are unidentified. (Courtesy of Kenneth Hoffman.)

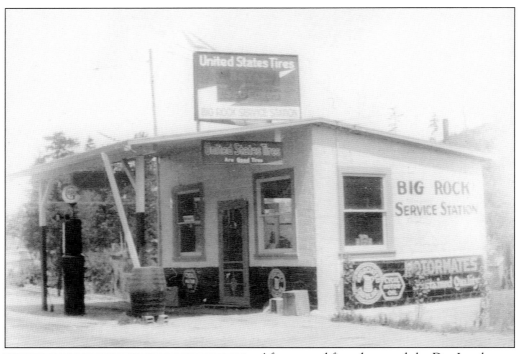

*John "Jake" Schopf and son - Jan. 1932*

After several fires destroyed the Day Lumber Company mill at Big Lake, John "Jake" Schopf, the mill superintendent, became unemployed and purchased land near Big Rock. He built the Big Rock Service Station and a home across the street. The business did quite well. However, following the Depression, he generously gave credit to many people in need, even though many never repaid his trust. (Courtesy of John Schopf Jr.)

John "Jake" Schopf Jr. was born in 1931. Eventually John Schopf lost everything and left the business to his brother August, moving to Everett with his family in 1934. He was remembered as a quiet man of great kindness, cheerfulness, and generosity. The Big Rock Service Station, known to first sell gas and groceries, later became a popular café and bar. (Courtesy of John Schopf Jr.)

# *Nine*

# AFTER THE MILLS

The lack of access to timber, a major fire, and bankruptcy closed the Day Lumber Company. Jobs in the company town were gone, and homes even lost their electricity, as the mill had provided it. The company's landholdings, equipment, and company houses were sold. Sedro-Woolley investors purchased the company ranch. Big Lake was left with a school, church, small farms, and a few resorts. People from Seattle began investing in lakefront property for recreational use, and many summer cabins were built. Dance pavilions were also built during this time. People came from all over to drink, dance, and listen to the music of local bands at popular Darrel and Billy Boys, Glen Allen's, and Green's Resort. These resorts were removed from town, allowing bootleggers to do business without interference from the law. The school and church remained and provided the community's identity and unity. The resilience of local people kept the small community going. The local PTA and ladies club provided outlets for community support and activities. As time progressed, the English Logging Company and Skagit Steel in Sedro-Woolley provided new opportunities for employment. Though the company town died, the community did not, and it continues today thanks to the residents whose families have made the valley home for decades and a whole new group of inhabitants who also appreciate the quiet beauty of country living in the Big Lake Valley.

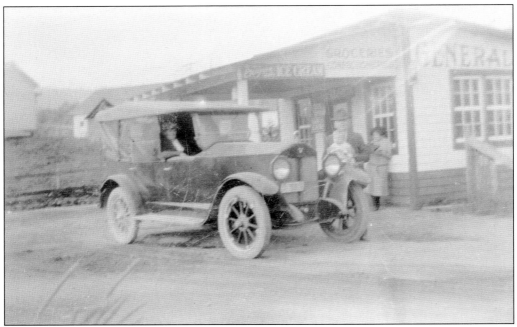

Starting in the 1920s, a service station sat on the corner of State Road 9 and West Big Lake Boulevard. Behind the service station was a large house, known for many years as the Hayes or Greathouse home, which served as a private home and boardinghouse for mill workers. The gas station contained a small grocery store. The 10-acre property supported strawberries, raspberries, fruit trees, and a herd of 10 dairy cows. (BLHS.)

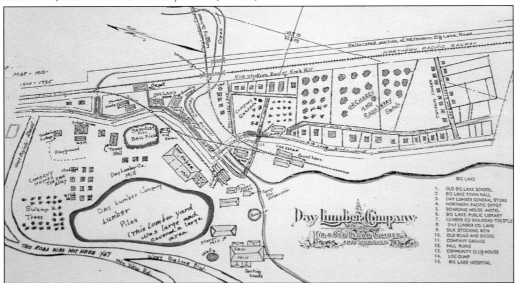

This map, showing the layout of the town, mill, and community, is a reconstruction using a 1925 county road map that showed the original roads and store. Collaborating with Josephine Hoffman, Ralph Willis, and Fred Meyers, all of whom had grown up in the mill town, Melba Hoffman Hall was able to reconstruct the site using the road lines and old photographs. Everyone agreed that the map was very accurate. (BLHS.)

Following the Day Lumber Company fire of 1925, the Big Lake community did not have a major grocery store for several years. Earnest Johnson saw the need for a store, as well as a place for his widowed daughter Alvan Swanson to make a living for her and her daughters. Johnson bought three small buildings left from the mill and put them together to construct the Big Lake Store. The store was purchased by Hale Beecher in the 1940s and later sold to Ben Palmer. Below, Herb and Geraldine Drummond, with their sons, posed in front of Beechers in the late 1940s. (Both, BLHS.)

After the 1923 fire that destroyed the original school, children attended school in the teacher's cottage, which had survived the fire. The local church was also utilized for schoolrooms while the temporary school buildings were constructed. Two buildings were constructed behind the teacher's cottage. These temporary buildings became the Big Lake School for 17 years. Big Lake's third school was built with government funding and was completed in 1937. The two-story building had three classrooms upstairs, and the basement housed a classroom along with a kitchen, lunchroom, small library, and restrooms. This structure is part of the present school building. (Both, BLHS.)

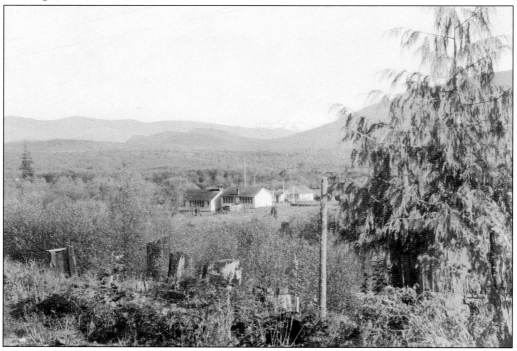

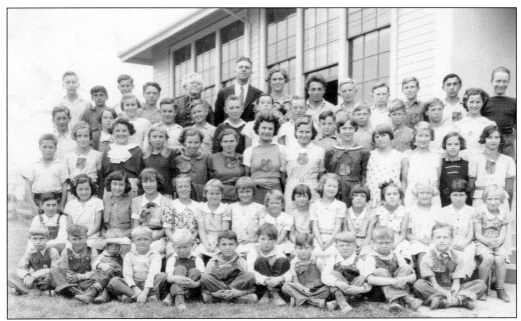

Standing in the fifth row behind the 1937 Big Lake School student body are Warren Granger (sixth from left) and his wife, Ruth (seventh from left), along with a Mrs. Beal (fifth from left). As time went on, the shortage of students in the Ehrlich, the Finn Settlement, Montborne, and Baker Heights schools forced those schools to consolidate with Big Lake. When the valley schools consolidated, the number of students at Big Lake School increased to the point that an addition to the school was needed. The tennis courts at the south end of the school and the porch on the west side of the school were removed to add a classroom, small library, and new restrooms around 1947. This was the first of several additions to the school. (Both, BLHS.)

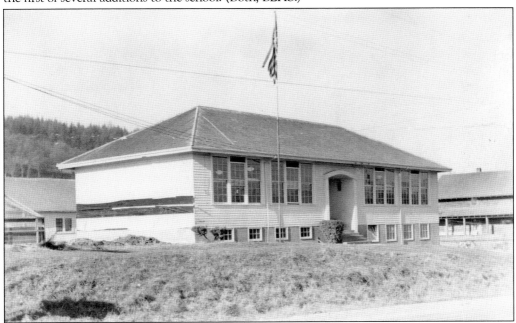

On a spring day in 1947, the graduating class of Big Lake School proudly waves their diplomas. Having completed the eighth grade, the next fall they would enter Sedro-Woolley High School. From left to right are (first row) Berniece Proctor, Donna Young, Myrtle Wold, Reta Chase, and Isabelle Simmons; (second row) David Gribble, Robert Bailey, Doug Ammons, and Bernard Hansen. (BLHS.)

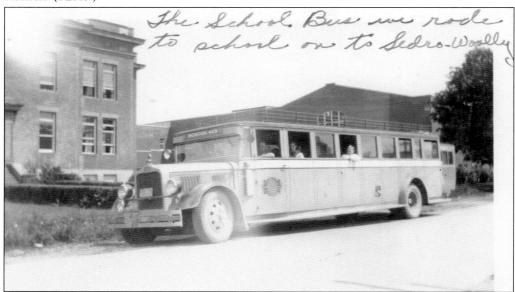

For many years, students who wanted to attend high school moved into either Mount Vernon or Sedro-Woolley, often living with a family and working for their room and board. Several were driven by car; roads were so bad that sometimes students literally pushed their cars through mud to get to school. Beginning in the 1930s, a school bus transported students from Big Lake to Sedro-Woolley High School. (BLHS.)

The church was built close to State Road 9 in 1917. As time went on, the church location became dangerous for children. When an automobile on the highway struck a young boy, the congregation decided it was time to move. Hillside property to the south was donated. With tremendous help from the community, along with the local volunteer fire department, a new building was completed in the 1950s. (BLHS.)

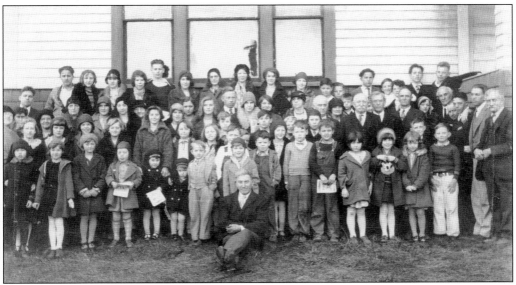

Families gathered in front of the old church for a photograph in 1931. The community was growing, with new families arriving to look for land and jobs. The English Logging Company was still operating nearby. Large social gatherings were common, and people would row their boats across the lake to attend church. (BLHS.)

In 1926 and 1927, Bill Drummond built a dance pavilion extending over a small portion of the Big Lake shoreline. He held popular dances on Thursday nights and Scandinavian dances on Saturday nights. When Prohibition was repealed, Harold Crane leased the hall, served drinks, and held dances. Herb Drummond, Bill's grandson, is standing in front of the pavilion. A few years later, the pavilion was destroyed by fire. (BLHS.)

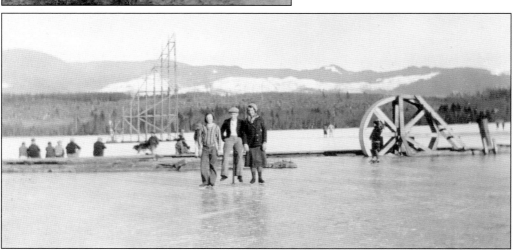

Green's Resort had a very high diving tower that divers used at their own risk in 1930. This tower caught fire and burned down; later, it was replaced with a shorter tower. The resort also provided boats, water bikes, a boathouse, and a small store. During freezing winters, ice-skating was popular on the lake. The skaters are, from left to right, Wallace, Gordon, and Ardys Ellstad. (BLHS.)

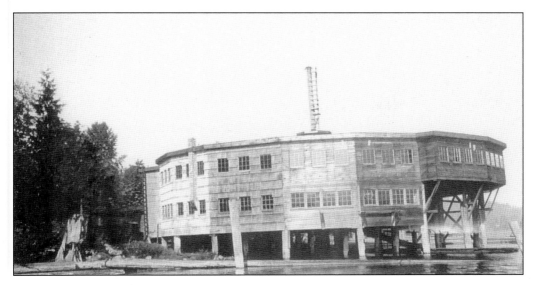

Judd Green began to add a pavilion to Green's Resort. His plan was to extend the pavilion out into the lake. Against all advice but with the help of many local men, the building was erected in 1931. The pavilion had living quarters on the first floor, along with lockers and changing cubicles for swimmers. There were two stairways that led up to the second floor, where the dance hall and cloakroom were located. During high water on the lake, the dance pavilion stood firm. People came from far away to dance the first night it opened. The crowd was large, and everyone was let in; at one point, the pavilion began to sway, so the dancers were sent out, divided in half. The first group danced for a while and then left, allowing the other half to come in to enjoy the new pavilion. Many different bands played at Green's Resort over the years. (Both, BLHS.)

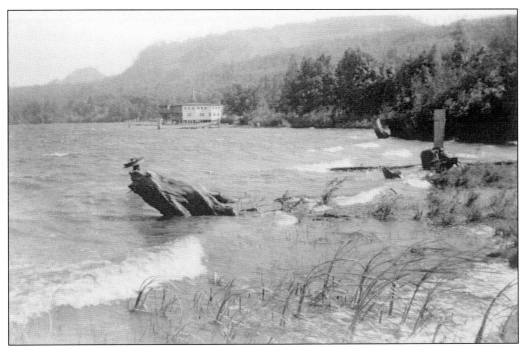

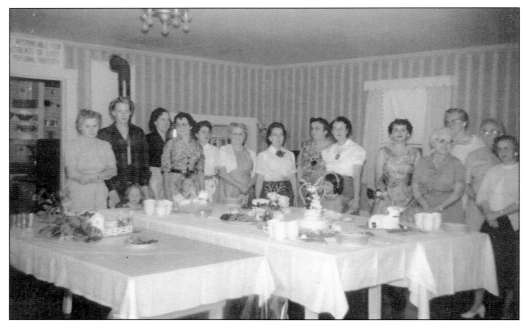

A group of local women formed a community club in 1936. They purchased an unused Day Lumber Company house for $79. Over the years, the building was fixed up and used for many socials and meetings. The ladies made quilts for people in the community and raised money for charities. The clubhouse also held many wedding and baby showers for the local girls. (BLHS.)

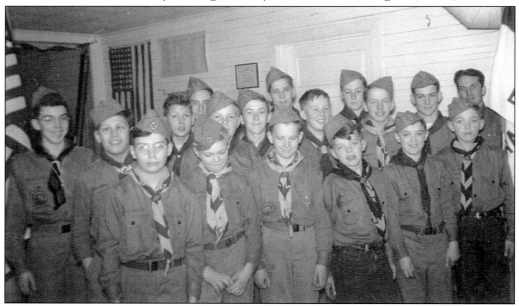

The clubhouse was home to the local Boy Scout troop for many years. Shown in this 1947 photograph are, from left to right, (first row) Jerry Parks, Lyle Strickland, Ben Chase, Larry Brigham, Steve Drummond, and Bill Brigham; (second row) Jerry Simmons, Barry Hussloen, Don Wirta, Bernard Hanson, Dick Moore, Kenneth Gribble, Fred Moore, and Scoutmaster Harold Gribble; (third row) David Gribble, Larry Thomas, George Freese, and William Wascisin. (BLHS.)

# *Ten*

# CHANGING TIMES

After Prohibition, the Great Depression, and World War II, a new era began for the residents of Big Lake Valley. With the lumber industry no longer the main employer in the area, many left in search of jobs. Economic growth was slow in the 1950s, but the farms and a few small businesses remained.

Many of the homes built by the Day Lumber Company along the lake became vacation homes for families that worked elsewhere. Water lines and a sewer system were installed around the lake. By the 1980s, the valley once again began to grow.

Commuting soon became commonplace for young families who wanted their children to live and grow up in a small community with a good school. Big Lake Elementary remains part of the Sedro-Woolley School District, with students being transported to middle and high school.

Fire District No. 9 has been an independent volunteer fire department since the late 1940s. It works closely with neighboring towns to provide emergency services and fire protection for approximately 5,000 residents.

The easy access to a wide variety of recreational activities, such as boating, fishing, hiking, and biking, have encouraged newly retired families to make their home in the valley. It may be difficult for new residents to visualize how much life has changed in the past 100 years and how much has stayed the same.

The Day Lumber Company owned the 3,000-acre Walking M Ranch, east of the mill at Big Lake, where cattle were raised to supply meat and dairy to mill laborers. The first barn was built in 1909 and 1910, and Joseph Thompson and Arthur Tripp constructed the second barn in 1914. Frank and Florence Roberson were the first to manage the ranch. The Day Lumber Company sold the Walking M Ranch to three Skagit Steel businessmen from Sedro-Woolley, Fred Fellows, Sidney McIntyre, and Wyman McClintock. Hector Hart Lindbloom was their ranch manager, and he held that position until 1942. Skagit Steel used Otter Pond on the ranch to test equipment being built at its plant. Today, the ranch continues to be farmed; some of the property has been developed into a planned residential community called Nookachamp Hills. (Both, BLHS.)

Ben Palmer and his wife, Martha, bought the store and gas station in 1949. It was both a home and a business for them and their two children, Martha Mary and Ben Jr., shown at right. Martha Mary worked at the store after her mother died in 1952 until the store was sold in 1962. Equipped with a full-service lunch counter and soda fountain, the store was much appreciated by the local residents. Voter registration was accepted; electrical and phone bills could be paid at the counter. Mike and Tamara McCoy have owned the store since 2002. The store continues to thrive, although the gas station no longer operates. (Right, courtesy of Jackie Anderson Faupel; below, BLHS.)

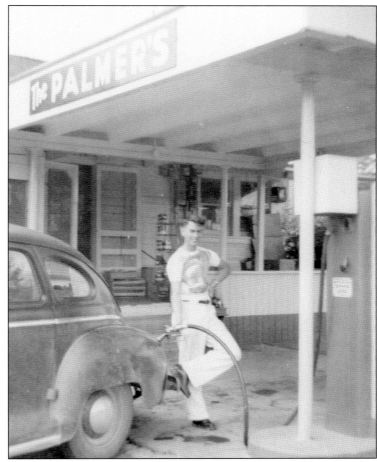

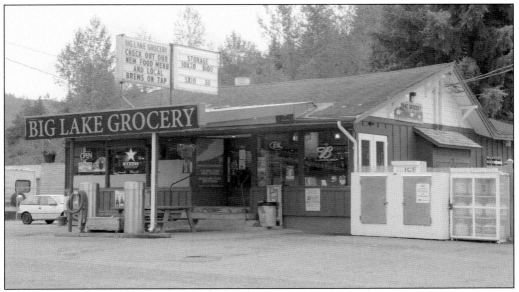

Land owned by J.H. Parker, Annie C. Parker, and W.A. Parker was transferred in 1899 to Annie C. Thompson. Joseph Thompson built the house, and county records reflect that home construction ended in 1915. John W. Hansen and Erna Hansen purchased the home and property on November 29, 1950. Hansen died in 1973, and in 1983, his son Neil Hansen began turning the farmland into a nine-hole golf course. In 1985, the new Overlook Golf Course held its grand opening. The house remains today, the barn has been replaced with a pro shop, and the golf course is a favorite for many enjoying nine holes of golf and the view of Big Lake. (Above, courtesy of Neil Hansen; left, courtesy of Neil Hansen and Aerial Photo, Inc.)

The round pavilion once known as Green's Resort was a popular spot from the 1930s to 1950s. The grounds were a favorite for swimming, boating, and picnicking. The pavilion is now an apartment building owned by Charles and Lisa Mehrmann; the Big Lake RV Resort occupies the remaining property. (BLHS.)

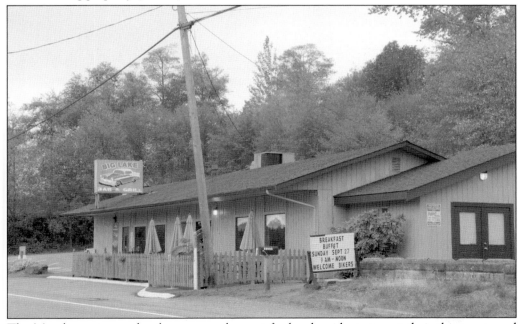

The Montborne tavern has been a popular spot for local residents to wet their thirst, eat, and dance. Located at the corner of State Road 9 and Montborne Road, previously Lafayette Street, the tavern, now the Big Lake Bar and Grill, is owned by Stephen Williams and is still a lively gathering place. (BLHS).

The need for a handicap ramp evolved into an update of Big Lake Community Church of the Nazarene in 2002. Local architect Lou Saint John donated plans, and Fisher and Sons Construction, along with many community members, volunteered labor to complete the building, giving the church a new look to fit in to the growing community. (BLHS.)

In the mid-1970s, Big Lake School closed, and students were bussed to Clear Lake. Public demand forced the school to be reopened after two years. Big Lake Elementary has grown in size and stature. Quality education for more than 300 students from kindergarten through sixth grade has resulted in excellent test scores. (BLHS.)

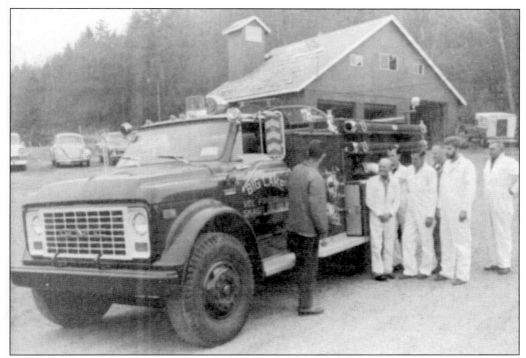

Big Lake Fire Department's new 750-gallon-per minute pumper truck arrived in 1972 and was inspected by members of the volunteer department, from left to right, Earl Holt, Fred Moore, Carl Overby, Lyle Robbins, Mike Simmons, and Duke Murden. The same crew spent the day refurbishing the roof on the firehouse seen in the background. (Don Anderson photograph, *Skagit Valley Herald*; courtesy of Big Lake Fire Department.)

A crowd gathered on June 21, 2014, to celebrate the opening of the new firehouse and training center. Speaking at the podium is Dean Shelton; seated to his right are fire chief Brett Berg, Bruce Thompson, Robert Guy, and Ken Dahlstedt. The old fire hall has become home to the local Boy Scout troop, as well as a fitness center for the volunteers. (BLHS.)

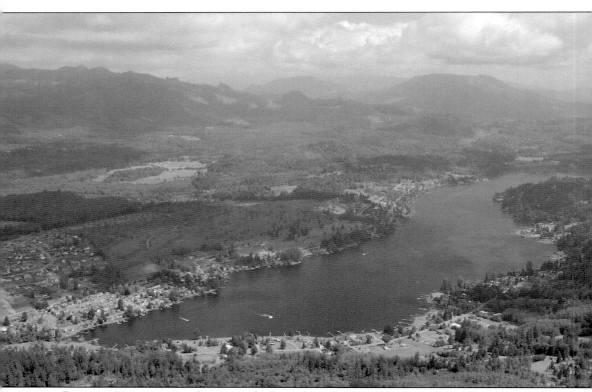

For over 130 years, many changes in the Big Lake Valley have been witnessed. The lumber industry is gone, and employment is found elsewhere. Where once small farms operated, many subdivisions are seen. However, one particular thing has not changed. The people and communities remain strongly connected, working together to preserve the quality of life for future generations. For the past 130 years, the Big Lake Valley has seen the arrival of new citizens, the removal of old-growth forests, the building of a lumber industry, and its disappearance. Small towns and schools have come and gone. The early 1970s saw the removal of the railroad tracks. Subdivisions have been built on farmland, yet many farms remain. As the changes gather increasing speed, the communities remain connected through the school and the desire to preserve the quality of life for future generations. (BLHS.)

# BIBLIOGRAPHY

Andrews, Ralph W. *This Was Sawmilling*. Atglen, PA: Schiffer Publishing Co., 1994.

Carlson, Linda. *Company Towns of the Pacific Northwest*. Seattle: University of Washington Press, 2003.

Collins, June McCormick. *Valley of the Spirits: The Upper Skagit Indians of Western Washington*. Seattle: University of Washington Press, 1974.

Sampson, Chief Martin J. *Indians of Skagit County*. LaConner, WA: Skagit County Historical Society, 1972.

Shiach, William Sidney, ed. *An Illustrated History of Skagit and Snohomish Counties*. Spokane, WA: Interstate Publishing Co., 1906.

Thompson, Dennis Blake. *Logging Railroads of Skagit County*. Seattle: North West Short Line, 1989.

Willis, Margaret, ed. *Chechacos All, The Pioneering of Skagit*. LaConner, WA: Skagit County Historical Society, 1973.

———. *Skagit Settlers, Trials and Triumphs 1890–1920*. LaConner, WA: Skagit County Historical Society, 1975.

Van Liew, Alice A., and John Johnson. *Skidroads, Stumps and Scuttlebutt*. Mount Vernon, WA: self-published, 1994.

# DISCOVER THOUSANDS OF LOCAL HISTORY BOOKS FEATURING MILLIONS OF VINTAGE IMAGES

Arcadia Publishing, the leading local history publisher in the United States, is committed to making history accessible and meaningful through publishing books that celebrate and preserve the heritage of America's people and places.

Find more books like this at
**www.arcadiapublishing.com**

Search for your hometown history, your old stomping grounds, and even your favorite sports team.

Consistent with our mission to preserve history on a local level, this book was printed in South Carolina on American-made paper and manufactured entirely in the United States. Products carrying the accredited Forest Stewardship Council (FSC) label are printed on 100 percent FSC-certified paper.

**MADE IN THE USA**